POSTCARD HISTORY SERIES

York

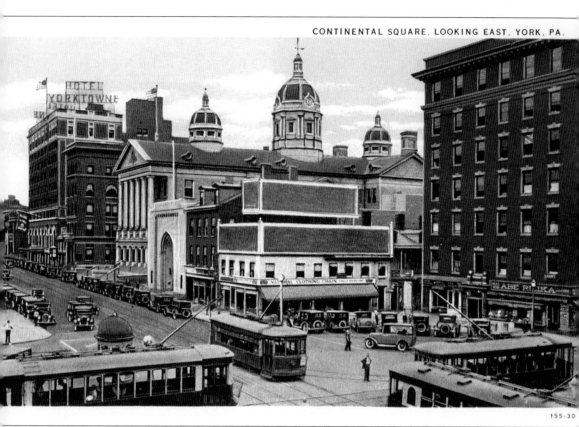

155-30

Horse-drawn trolleys were introduced in York in 1886, followed by electric trolleys in the 1890s. The first automobile to drive the streets of York did so in 1904, but the first decade of the 20th century saw mainly horse-drawn carriages sharing the road with electric trolleys. This view is the south side of the first block of East Market Street. In 1913, Market Street became part of the famed Lincoln Highway.

POSTCARD HISTORY SERIES

York

Scott D. Butcher

ARCADIA

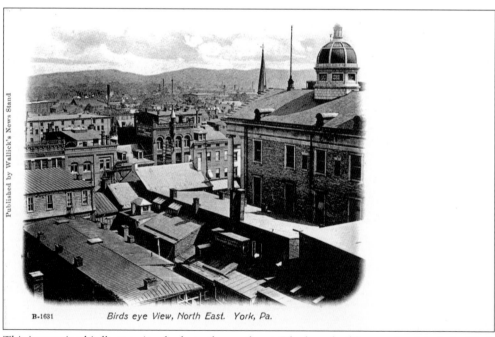

This interesting bird's-eye view looks to the northeast. The large building to the right is the York County Court House, prior to its expansion. To the left of the courthouse is the Pollack Building, which stood on East Market Street until it was destroyed by fire.

CONTENTS

ACKNOWLEDGMENTS

This book in the Postcard History series was on the fast track from its inception to the time it was delivered to Arcadia Publishing. In fact, the time between acceptance of the book proposal and delivery of the book was about five weeks. Many long nights and weekends were spent with my head buried in history books or my fingers glued to a keyboard. Special thanks go to my beautiful wife, Deborah Butcher, for her love and patience. Also, this book could not have happened without the help of Ed Null, who graciously loaned me his extensive postcard collection to supplement my own. Karen Arnold, Jim McClure, Georg Sheets, Gordon Freireich, Genevieve Ray, Gene Schenck, and Michael Helfrich also provided helpful insight to my inquiries, and I am thankful for their assistance. Finally, a special thank-you goes to Arcadia Publishing for making this project a reality. Arcadia's postcard series provides a unique forum for capturing a bygone era.

INTRODUCTION

York was founded in 1741, making it one of the oldest American towns west of the Susquehanna River. A site was chosen at the intersection of the Monocacy Trail and Codorus Creek at a location where wagons could easily cross. Thomas Cookson, deputy surveyor for the Penn family, laid out York in grid formation, similar to Philadelphia. In these early years, York was a frontier community. The surrounding farmland had been settled beginning in the 1730s by German, Quaker, and Scotch-Irish families. Even though many of the local settlers were German, the English influence can be seen in the selected street names: King, Queen, Princess, George.

With the onset of the American Revolution, York was the first non–New England town to send soldiers in the fight against the British. The Second Continental Congress called York Town (as it was then known) home from 1777 to 1778. While here, the the Continental Congress debated and adopted the Articles of Confederation, the nation's first constitution; declared the first National Day of Thanksgiving for a Continental army victory over the British in Saratoga, New York; and ratified treaties of alliance and friendship with France, an important ally. Patriots such as John Adams, Sam Adams, John Witherspoon, Thomas Paine, and many others walked the streets of York.

In subsequent years York grew from a sleepy frontier town to a regional center of agriculture and industry. In June 1863, York became the largest northern town to be occupied by the Confederate army in the Civil War. On the eve of the invasion, the town's leaders decided to negotiate with the Southern soldiers. The Pennsylvania militia would offer no resistance; in turn, the Confederate army would leave the town unharmed. In reality, Gen. Jubal Early demanded a major ransom of food, clothing, and money in order to have the town spared. York was occupied for the three days leading up to the Battle of Gettysburg. The decision to peacefully surrender the town—viewed as very controversial and unpatriotic by some at the time—saved York's magnificent architecture for future generations to enjoy.

During the Reconstruction era, York continued to grow. Industrial know-how was key to York's success. The first American coal-burning locomotive was created in York, as was the nation's first iron steamboat. In the early 20th century, York prospered. A major, local automobile industry earned York the nickname "Detroit East," while the agrarian roots of the area played out in the tobacco industry: in 1920, a full 20 percent of all American-made cigars came from York County. Market Street—the Lincoln Highway—became home to a vibrant retail district. Streetcars connected York with the suburbs—and eventually all of York County. Beautiful buildings were constructed; some remain intact, some have been altered, and some,

unfortunately, are no longer with us.

This postcard history captures York in the early and mid-20th century, painting the picture of a vibrant and dynamic community. To many, this was York's golden era. Keep in mind when viewing the images that you are viewing *postcards*—some are 100 years old, some have been in basements or attics for decades, and some were slightly damaged in the mail. But this gives them character, not unlike the character of the town they so beautifully portray.

One
CENTRE SQUARE

Centre Square is more than a part of York. In many ways, it *is* York. In 1741, York Town was laid out and patterned after Philadelphia's checkerboard design. Centre Square was situated two blocks east of the Codorus Creek and was designed to be the town center. In the 1750s, the York County Court House was constructed in the middle of Centre Square, creating a traffic "circle" around it. After it was torn down in 1841, large market sheds took its place, and remained there until the 1880s. Soon after the sheds were demolished, trolley service began, and Centre Square was large enough to handle several trolleys at once. In the 1920s, Centre Square came to be known as Continental Square in honor of the Second Continental Congress, which actually adopted the Articles of Confederation in the middle of Centre Square. The "Square"—as it is known by the locals—has been the center of many major celebrations. It has been the focal point for parades and holiday decorations and a desirable address for businesses for over 250 years.

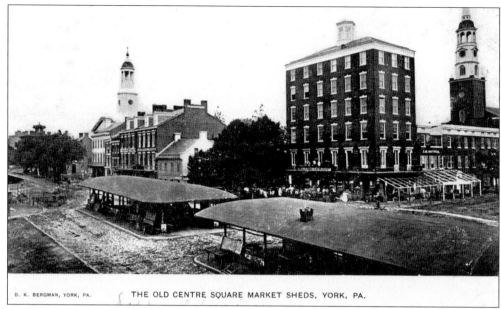

THE OLD CENTRE SQUARE MARKET SHEDS, YORK, PA.

In the early 1840s, a market shed was constructed in Centre Square, taking the place of the York County Court House and State House, which were both demolished in 1841. In 1844, a second market shed was built that included police headquarters and a lockup underneath. Twenty men, seven mules, and three horses demolished the sheds on the night of June 30, 1886, much to the dismay of many townspeople.

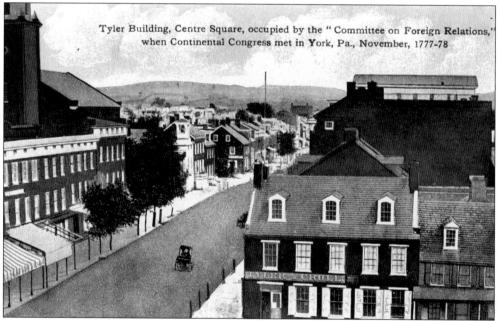

This view is of the southwest quadrant of Centre Square and South George Street. The building with the Tyler & Croll sign hosted the Committee on Foreign Relations while York was the national capital. Patriot Thomas Paine served as secretary to this committee. Later, a noted local tailor would occupy this building. Isaac Singer, inventor of the Singer sewing machine, worked here as a journeyman.

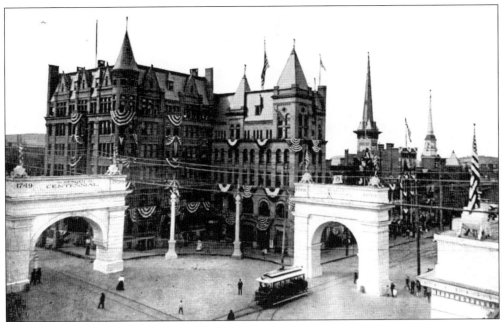

The year of 1899 was a festive one in York, as it was the 150th anniversary of the creation of York County. Four temporary triumphal arches were erected in Centre Square, and each measured 40 feet wide by 30 feet high by 12 feet deep. This "Court of Honor" was illuminated at night by several thousand lights. A multi-day celebration included lectures about York's history, a pageant, and an industrial parade witnessed by upwards of 100,000 people.

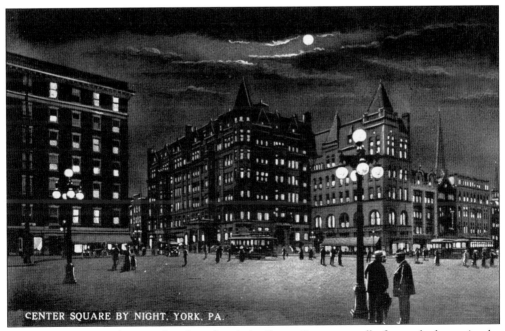

This nighttime view shows a city alive after dark. Centre Square actually featured a large circular pattern that accommodated multiple trolley cars at the same time. Gas street lamps appeared in York *c.* 1850 and were used until 1887, at which time electric street lamps were incorporated.

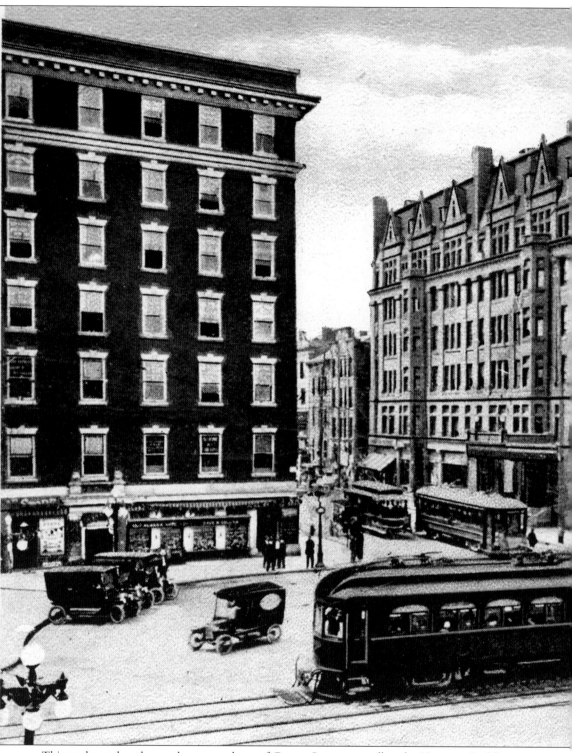

This angle catches the southwest quadrant of Centre Square as well as the Hartman Building, on the southeast quadrant. The largest building is the 1890 Colonial Hotel. The building on the far

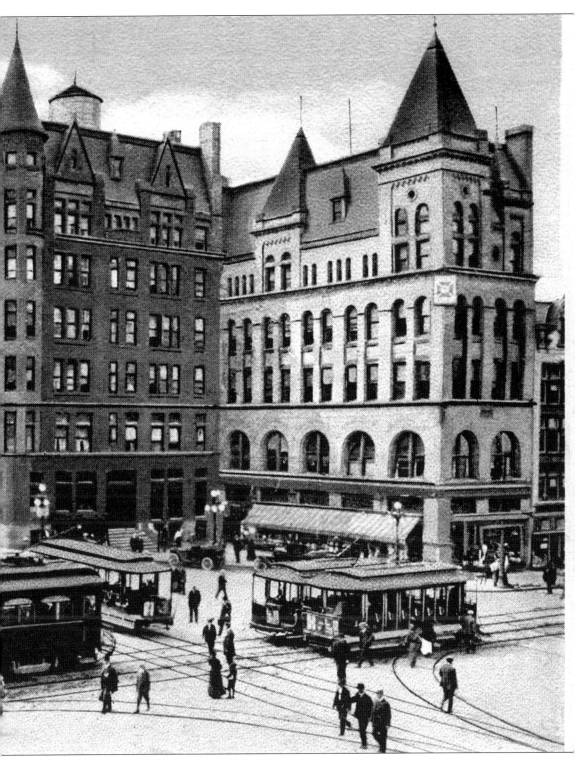

right is the Rupp Building, constructed in 1892.

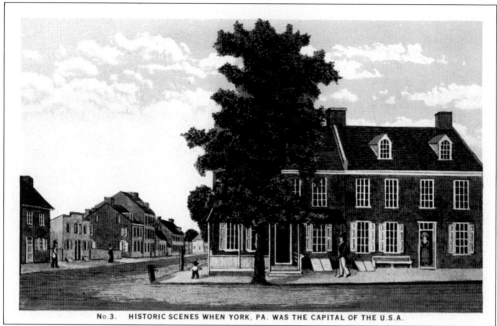

No.3. HISTORIC SCENES WHEN YORK, PA. WAS THE CAPITAL OF THE U.S.A.

This 1927 postcard of a William Wagner painting shows the northeastern quadrant of Centre Square, specifically the home of Archibald McClean (partially obscured by a tree) and its next-door neighbor. McClean was the principal surveyor of the Mason-Dixon line between the Susquehanna River and Allegheny Mountains. His home served as the U.S. Treasury while the Second Continental Congress met in York.

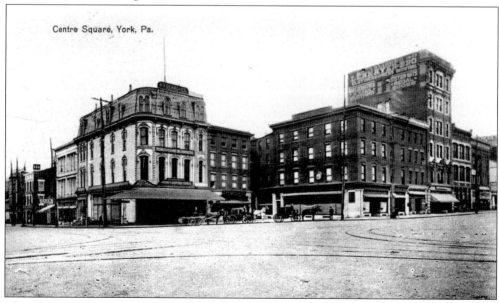

The most prominent structure in this early-20th-century Centre Square view is the Spahr Building, which features the Second Empire architectural style. The unique roof is known as a mansard roof. M. B. Spahr was a noted industrialist and community leader. The building bearing his name was constructed in the 19th century and was torn down in the early 1920s to make way for a bank.

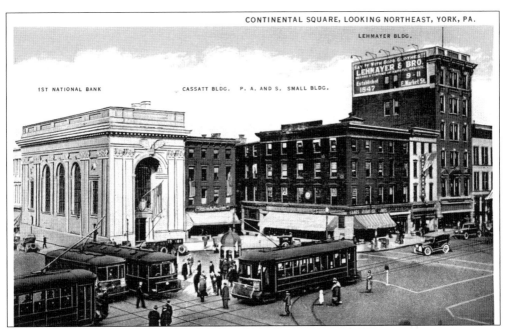

LEHMAYER BLDG.

1ST NATIONAL BANK CASSATT BLDG. P. A. AND S. SMALL BLDG.

SAY IT WITH GOOD CLOTHES!!
LEHMAYER & BRO.
Established 1847 9-11
E. Market St.

This view of Continental Square shows York before bus service was introduced. Note the trolley master's station in front of the Cassatt Building. Bus service was introduced in the late 1930s, and the last trolley ride occurred in 1939. The large building on the left was constructed as First National Bank. The location is appropriate because it was the site of the U.S. Treasury during York's tenure as capital of America.

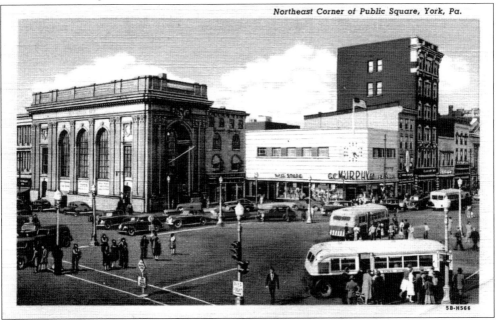

Northeast Corner of Public Square, York, Pa.

G. C. MURPHY

5B-H566

This postcard is the same view as above in the post-trolley era. The P. A. & S. Small Building has been replaced with G. C. Murphy Company, which opened in York *c.* 1940. The adjacent Cassatt Building was purchased one year later and remodeled to serve as an annex for the five-and-dime store.

The tallest building of its day—in the center of this postcard—was constructed on the northwest quadrant of the Centre Square by William C. Goodridge, an African American who was a freed slave. Goodridge emerged as one of York's most prominent businessmen in the 1840s and 1850s, owning 12 buildings, as well as the Reliance Line of rail cars—13 in total. Goodridge was also a conductor on the Underground Railroad, and both his properties and rail cars had hidden compartments. It is believed that Osborne Perry Anderson, an African American who took part in John Brown's raid on Harpers Ferry, was hidden on Centre Square on his way to Canada.

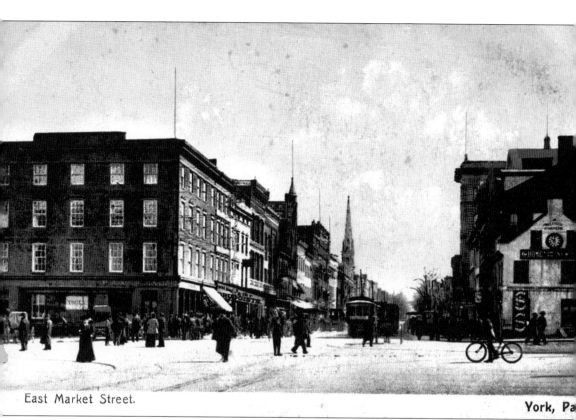

East Market Street.

York, Pa

The two-and-a-half-story building on the southeastern quadrant of Centre Square (right side) has been standing since originally constructed in the early 1800s as the Golden Swan Tavern. For many years it was also known as the Weiser Building. In this building in 1925, Harvey Newswanger opened a one-room shoe store. That small store eventually grew and took over the entire building in 1932.

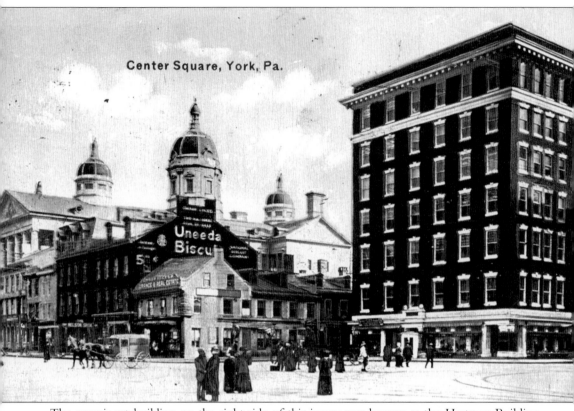

Center Square, York, Pa.

The prominent building on the right side of this image was known as the Hartman Building, named for the local merchant who constructed it to be taller than the Goodridge Building, across Centre Square. The building was originally six stories, with an additional story added later. The building is still standing today; however, the top stories were destroyed in a fire, and the building now has an aluminum facade.

Two
BUSINESS AND INDUSTRY

The downtown area was the center of York's retail universe in the early 20th century. The Bon-Ton, Jacks, Wiest's, and Bear's are some of the major department stores that have come and gone from the city. McCrory's, Murphy's, and Woolworth's have also vacated their place in the cityscape. Likewise, most of the hotels from this era—Colonial, Brooks, City, and Penn, to name a few—only remain in memories and pictures. Fortunately, York's crown jewel of lodging—the Yorktowne Hotel—is still very much a part of the local community. The postcards of York during this era paint a picture of prosperity, and for those actively involved with urban redevelopment, they also paint a picture of what can be once again.

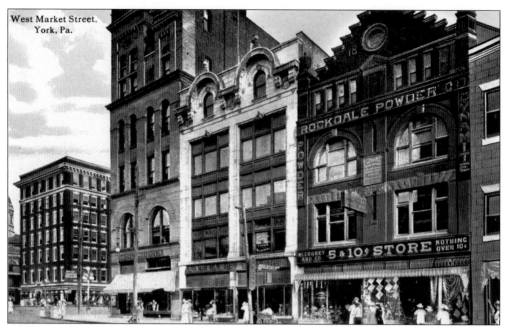

McCrory and Company 5 & 10 ¢ Store was a staple in "Main Street America" for decades. McCrory's, as the company came to be known, was actually headquartered in York. Note the sign on the building promoting Rockdale Powder Company, a local manufacturer of dynamite and powder for construction purposes.

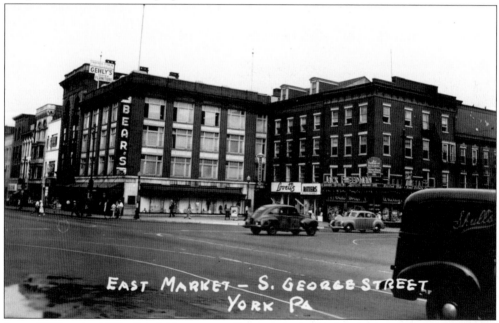

From 1888 to the 1970s, Bear's Department Store was a destination for everything from gifts to ready-to-wear clothing to the beauty salon and cafeteria. The original two-and-a-half-story building was so extensively remodeled and expanded in 1911 that it essentially became an entirely new structure. One year later Bear's became the first department store in York to use a motor-driven delivery truck.

F. W. Woolworth was founded in 1911 and was the first five-and-dime store to open on main streets throughout the United States. The chain grew throughout much of the 20th century, eventually closing in 1997. The York store opened on West Market Street in 1913 on the site of the German Reformed Church. For many years Phillip Livingston, a signer of the Declaration of Independence, was buried on this site.

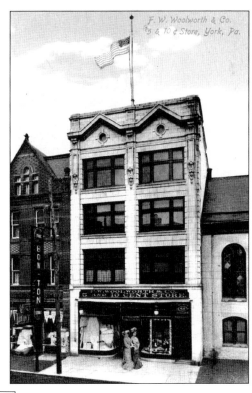

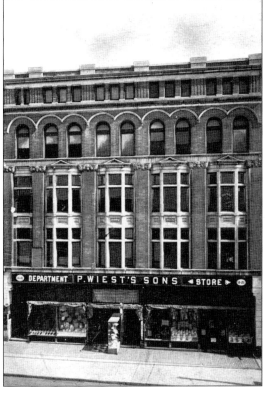

Founded in Dover in 1843 as a dry goods store, P. Wiest's Sons was a fixture on West Market Street in York in the late 19th century and throughout much of the 20th century. Their large department store was constructed in 1889 and expanded in 1895. It was also remodeled several times. "A great store in a great city" was the slogan for this popular department store.

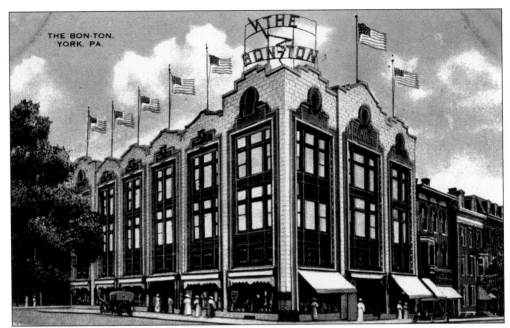

Max Grumbacher opened a one-room millinery and dry goods store on West Market Street in 1898. From these humble beginnings, the Bon-Ton has grown steadily to become, today, a major retail department store chain. The flagship store in this postcard was constructed in 1912 at the southwest corner of West Market and Beaver Streets. It was enlarged a decade later and, in 1956, became home to York's first moving stairway.

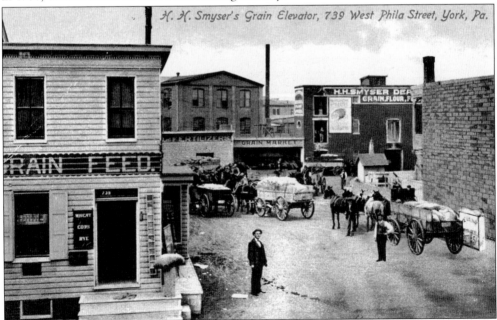

This grain dealer was located on the north side of West Philadelphia Street. York's agrarian roots are deep, and well into the 20th century, many city businesses were still associated with agriculture. Tobacco was another major industry in York in the early 1900s. In fact, by 1920, York County was producing 20 percent of American-made cigars.

This building housed multiple furniture stores over the years. C. A. Strack & Son occupied the building for several decades. Later, the Runkle Furniture Company purchased the building to relocate its store, which had been in operation since 1923. Eventually, the Bon-Ton Department Store relocated its furniture business, the Bon-Ton Store for Homes, to this location.

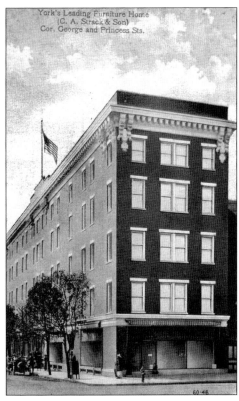

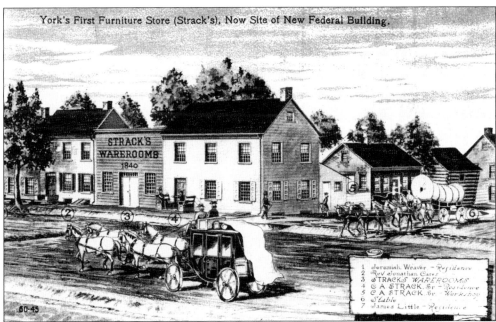

Charles A. Strack Sr. was born in Saxony, Germany, and came to America in 1838. A year later his family settled in York, and Strack became one of the earliest furniture dealers in town. His son, Charles A. Strack Jr., was born in 1843 and carried on the furniture business in addition to being an undertaker.

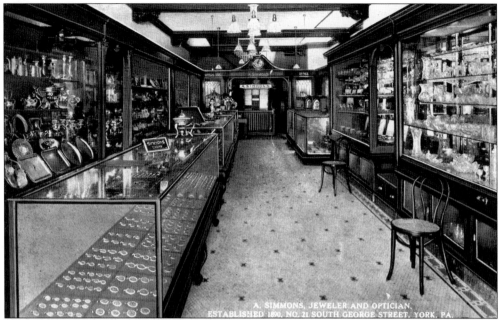

Pirosh S. Simmons, Jewelers, was located on the first block of South George Street. As evidenced in this postcard, watches, plates, and crystal were among the store's many offerings.

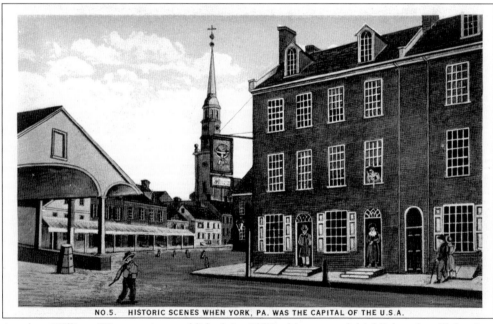

Another William Wagner view published in 1927, this postcard highlights the Globe Inn, evidenced by the globe on the sign. Over the years it was also known as McGrath's Hotel and the Stage Office. A hotel located at another location relocated here in 1820. In 1825, General Lafayette, a French nobleman who had spent time in York during the American Revolution, stayed here. The Rupp Building now stands at this site.

The Colonial Hotel, at the southwest corner of Continental Square, has been a fixture in York for over a century. It was constructed in the early 1890s and had a dining room on the top floor and 75 guestrooms when it first opened. It was expanded and renovated several times. Unfortunately, a major fire in 1947 destroyed the upper level, taking with it the conical turret roof and much of the mansard roof.

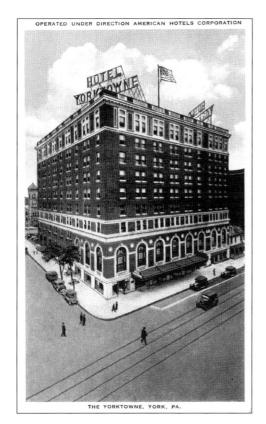

OPERATED UNDER DIRECTION AMERICAN HOTELS CORPORATION

THE YORKTOWNE, YORK, PA.

The Yorktowne Hotel has towered over downtown York since its construction in 1925. A year earlier, the chamber of commerce had organized a committee to look into the lack of adequate hotel space in York. The hotel opened with 198 guestrooms and was expanded several times in subsequent years. Today, the Yorktowne Hotel is a National Trust Historic Hotel of America.

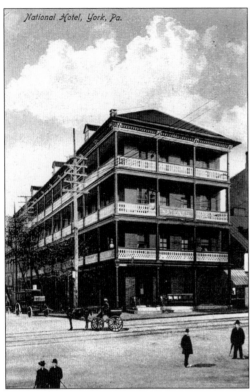

National Hotel, York, Pa.

"There we dined and I chose beefsteak, the best ever I have enjoyed." So wrote English novelist Charles Dickens about his 1842 visit to the National House on West Market Street. Dickens stopped in York during his travels between Baltimore and Harrisburg. Pres. Martin Van Buren stayed here in 1839. Even though train service was then available to York, Van Buren arrived by carriage.

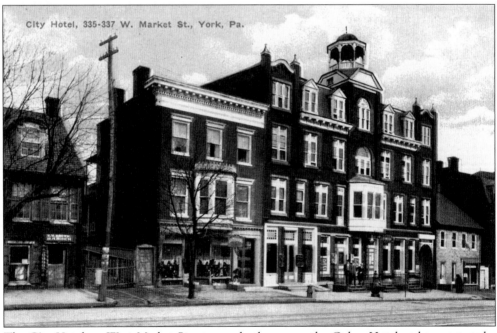

City Hotel, 335-337 W. Market St., York, Pa.

The City Hotel on West Market Street was also known as the Ocker Hotel and was a popular stop for wagoners heading westward. The buildings on either side are no longer standing; the hotel building still remains, however, although its appearance has changed over the years. Note the gazebo-like cupola, which is no longer present.

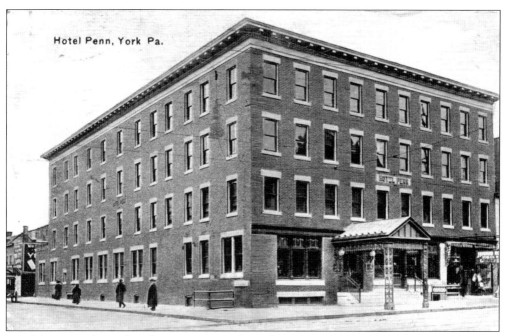

Hotel Penn was located at the intersection of North George and East Philadelphia Streets. The first hotel on this site, the Pennsylvania House, opened in 1863. This building was constructed in 1903. In its heyday, Hotel Penn was one of York's premiere hotels.

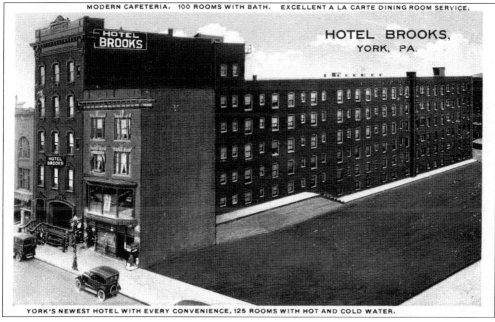

Located at 40 South George Street, the Hotel Brooks was established in 1914 and became a popular meeting place for local Democrat and Republican clubs, as well as the headquarters of the Tramerick Club, a social organization. By 1956, all 100 rooms of the hotel featured televisions, air-conditioning, and private baths.

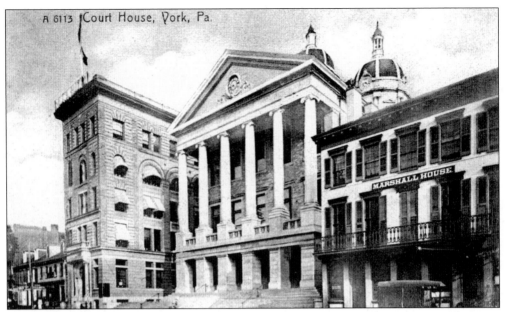

A former York County sheriff opened the Marshall House in the mid-1800s upon completion of his term. It was located next to the second York County Court House. Originally named for the sheriff, the Ginder House changed hands in 1905 and became known as the Marshall House. Eventually it was renamed the Baughman House before being demolished in the mid-20th century.

Constructed in 1738 by an English Quaker, this home was located along the Monocacy Road. While York was serving as the nation's capital, members of the Second Continental Congress frequented the inn. In the 19th century, it was again associated with freedom—the building was a station on the Underground Railroad. Ye Olde Valley Inn was dismantled in 1962 and reconstructed in Susquehanna Memorial Gardens.

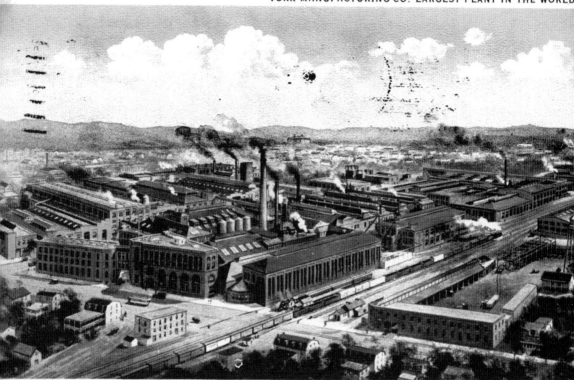

DEVOTED TO BUILDING ICE MAKING AND REFRIGERATING MACHINERY EXCLUSIVELY, YORK, PA. 90:

The York Manufacturing Company was established in 1874 by six men; 11 years later, the company built its first ice-making machine. YORK, as the company is known, installed air-conditioning in a theater in Alabama in 1914 and, in 1923, installed air-conditioning in an office building for the first time. The mammoth plant pictured in this postcard was located along West Philadelphia Street and Roosevelt Avenue.

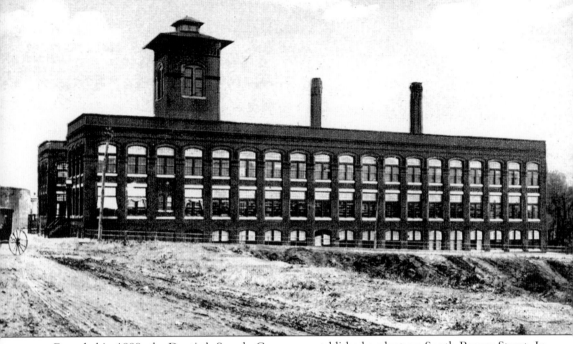

Dental Supply Company, York, Pa

Founded in 1899, the Dentist's Supply Company established a plant on South Beaver Street. In 1905, it purchased land on College Avenue where the main plant was constructed. Dentsply, as the company came to be known, grew into a world leader in artificial teeth and other dental products. A 1957 York Chamber of Commerce guide even refers to York as the "unofficial 'Tooth Capital' of the world."

Three
INSTITUTIONS

York boasts some of the oldest religious communities in Pennsylvania. Due to the heavy concentration of German settlers in York in the 18th century, Lutheran and Reformed (United Church of Christ) churches are commonplace. Christ Lutheran Church and First Presbyterian Church both stand on their original sites—land granted by the heirs of William Penn. Likewise, York's schools have a long and diverse history. The Episcopal Church of St. John the Baptist started York's first school of classical learning; it grew to become the York County Academy, eventually merging with the York Collegiate Institute to form the well-respected York College of Pennsylvania. Many of York's public schools were constructed around the beginning of the 20th century. Some remain as schools, some now house apartments, and some are no longer in existence. Both the historic churches and schools of York have a high degree of aesthetics and remain architecturally significant to this day.

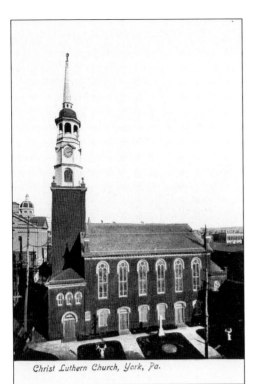

Christ Luthern Church, York, Pa.

The congregation of Christ Lutheran Church has the distinction of being the oldest Lutheran congregation west of the Susquehanna River. The plot of land on which this church stands was granted by the heirs of William Penn in 1741. A log church was built in 1743, and this church was completed in 1814. Many of York's settlers were German, and thus, most Lutheran churches originally held services in the language of the motherland.

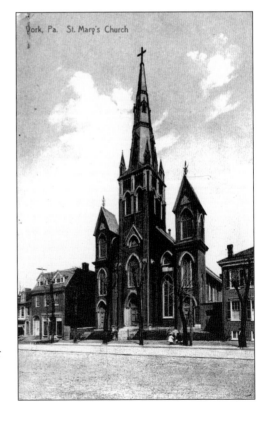

In 1852, a group of German Catholics left St. Patrick's Roman Catholic Church and founded St. Mary's Roman Catholic Church. This brick building was constructed in 1884, and a subsequent 1914 renovation gave the facade its current stone appearance. In 1920, an artist was commissioned to paint eight images of Mary on the sanctuary ceiling. Over the years these paintings were covered over and forgotten. Fortunately, they have since been rediscovered.

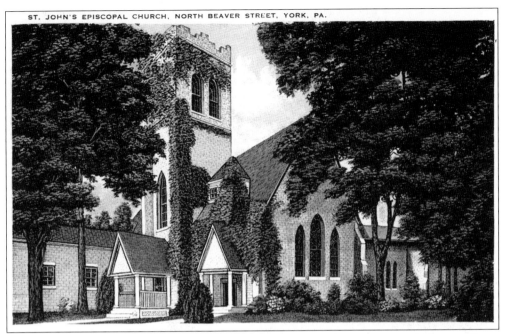

The Episcopal Church of St. John the Baptist has been a fixture on North Beaver Street since 1769. The congregation was founded in 1755 by the Society for the Propagation of the Gospel in Foreign Parts. During the American Revolution, the church was used as an arsenal. The congregation established York's first school of classical learning, which became the York County Academy.

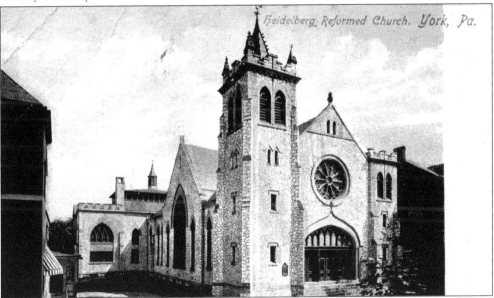

Organized in 1867, the Third Reformed Church of York originally met at the Masonic Hall on North Beaver Street. A few years later, a new church was constructed on North Duke Street, and in 1890, the name was changed to Heidelberg Reformed Church. This building was constructed in 1901, and today, more than a century later, it is still home to the congregation, now known as Heidelberg United Church of Christ.

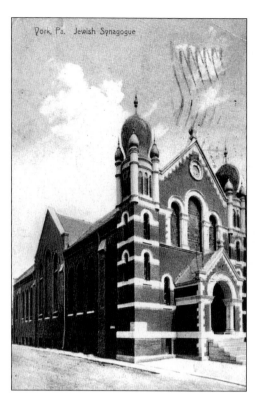

Constructed in 1907, the Temple Beth Israel building is located at 129 South Beaver Street. The congregation dates from 1877 and originally held services in homes and then in the Hartman Building on Centre Square. This building is unique in York for its copper onion domes. After the synagogue relocated to the suburbs in the early 1960s, the building changed hands several times and is today home to a Christian congregation.

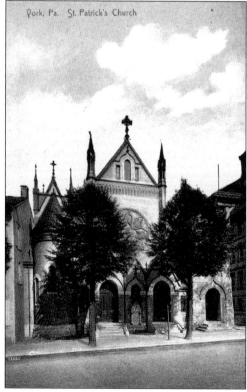

The congregation of St. Patrick's Roman Catholic Church dates from the 1740s and was originally attended by missionaries from surrounding areas. A house on this site became home to the congregation in 1776, with a new church being constructed in 1810. The current building opened in 1898 and was constructed at a cost of $40,000.

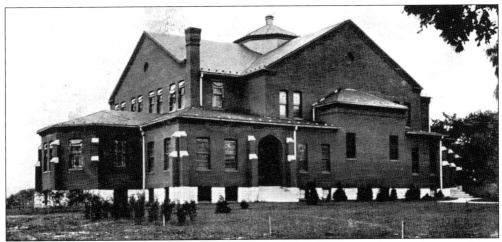

Organized with 10 members in 1889, St. Matthew's Lutheran Church was originally located on Carlisle Avenue between West Market and West Philadelphia Streets. As the church grew, the building was expanded. It soon became clear, however, that a larger site and new building would be needed. A large lot on West Market Street was purchased, and in 1906 this Sunday school chapel was constructed.

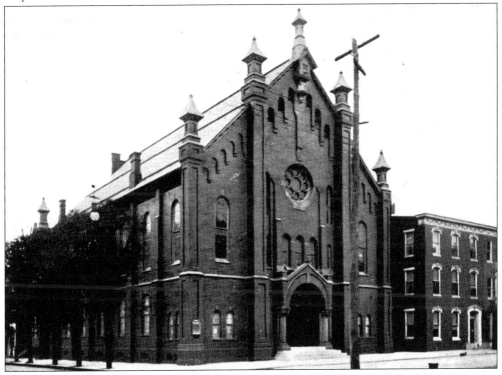

First Methodist Episcopal Church of York was incorporated in 1820, although the congregation was organized in 1782, worshipping in a simple building with a dirt floor. The congregation was the first in York to hold candlelight services. In 1836, a new building was erected on the northwest corner of Beaver and Philadelphia Streets. The building pictured here was constructed on the same site in 1873. The congregation still thrives today as Asbury United Methodist Church.

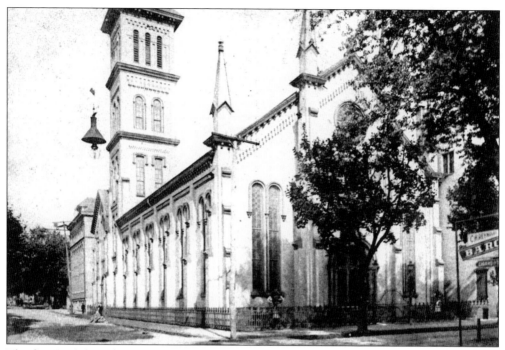

The first English Lutheran church in York was organized in 1836. The church built a house of worship a year later on the southeast corner of West King and South Beaver Streets. St. Paul's Evangelical Lutheran Church was rebuilt and dedicated in 1871 at a cost of $62,000. With a seating capacity of 800, it was one of the larger churches downtown. Today, the congregation is located on South George Street.

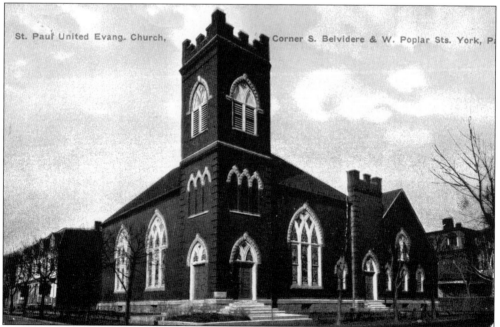

St. Paul's United Evangelical Church was founded in 1902. A small chapel was constructed that same year. In 1905, this new building was built at a cost of $12,000.

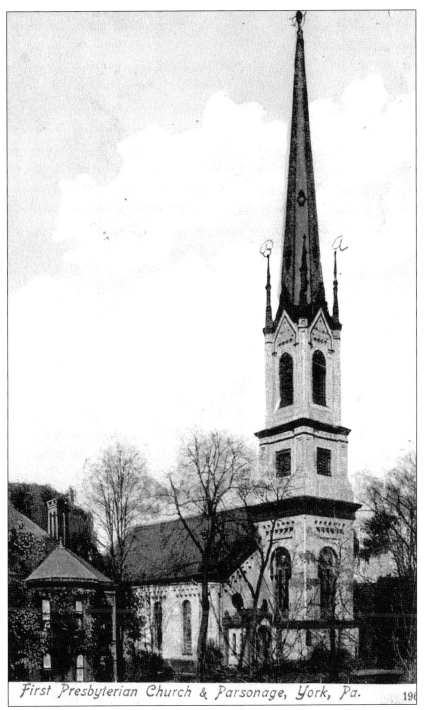

First Presbyterian Church & Parsonage, York, Pa. 196

In 1785, the heirs of William Penn granted a plot of land for the purpose of constructing a Presbyterian church and burial ground. A church was built in 1789. First Presbyterian Church has been a part of York for over 200 years, occupying the same site. The original building was demolished in 1860, and construction on this structure was begun. James Smith of York, a signer of the Declaration of Independence, is buried here.

37

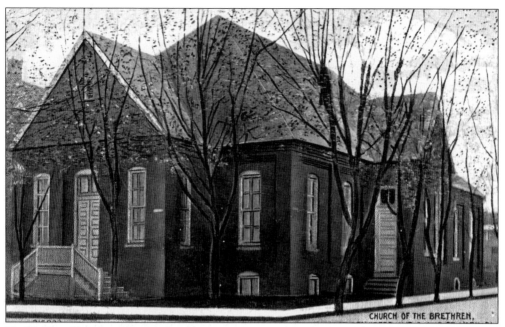

York's First Church of the Brethren has roots as a mission church of the Codorus Church of the Brethren. A church was constructed at the corner of West King Street and Belvidere Avenue in 1883 and replaced by a larger facility in 1900. The congregation remained here until 1964, when it relocated to the Haines Acres neighborhood east of York City.

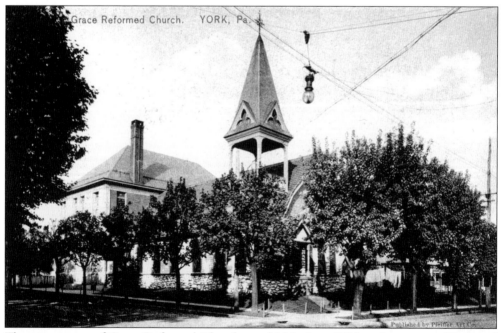

The cornerstone of Grace Reformed Church was laid in June 1886 at the corner of Park and Hartley Streets. The congregation was officially organized in 1888, when construction was completed. Its numbers had grown to almost 350 by 1907. Note the street light suspended from wires to illuminate the intersection.

Zion Evangelical Lutheran Church of York was organized in 1847 by English-speaking members of First Lutheran Church (Christ Lutheran) and was affiliated with that church until the 1860s. This building was constructed in 1851, expanded in 1869, and totally remodeled in 1907. This particular postcard was published to promote Rally Day in 1909.

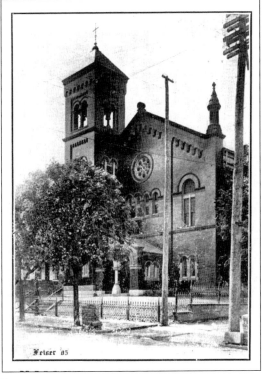

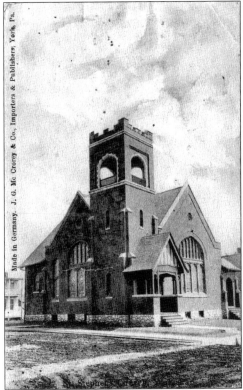

St. Stephen's Church was organized in 1903 in Eberton, today known as West York. A committee from Grace Reformed Church oversaw construction of a new building on Stanton Street, and the church was dedicated in 1905.

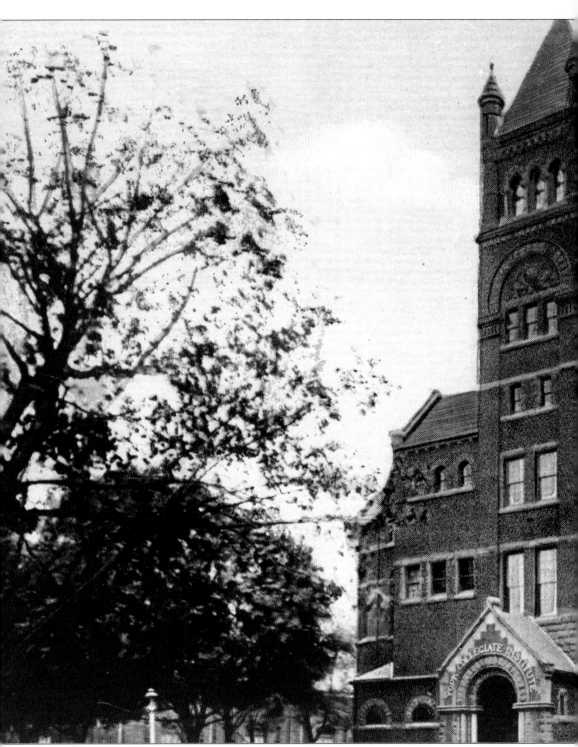

For several decades this beautiful building stood adjacent to the City Market, with its prominent towers defining the South Duke Street skyline. The York Collegiate Institute opened in 1873 as a liberal arts school. Their first building was destroyed by fire in 1885 and was replaced by this

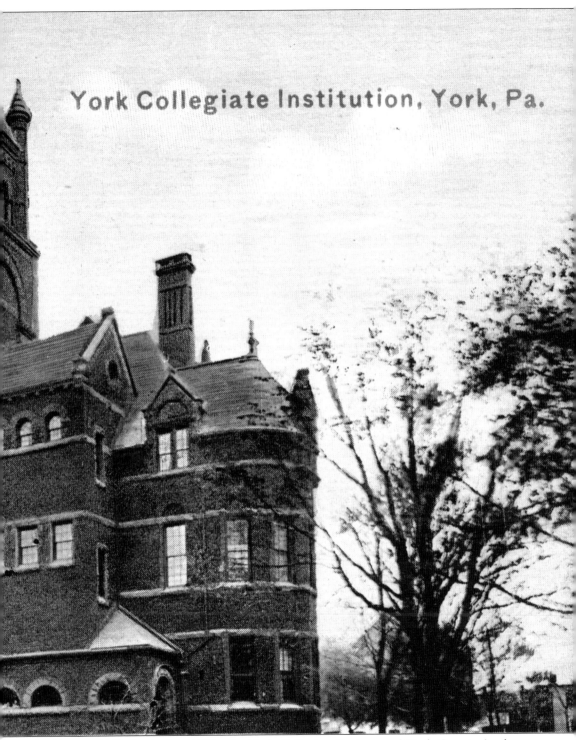

York Collegiate Institution, York, Pa.

building in 1887. In the late 1920s, the York Collegiate Institute and York County Academy began offering joint programs, and the two officially merged in 1941 as York Junior College.

In 1787, the Episcopal Church of St. John the Baptist opened the first school of classical learning west of the Susquehanna River. The York County Academy officially became a county school in 1799. The school operated well into the 20th century and, in 1929, began offering classes at the York Collegiate Institute, with which it eventually merged to form York Junior College.

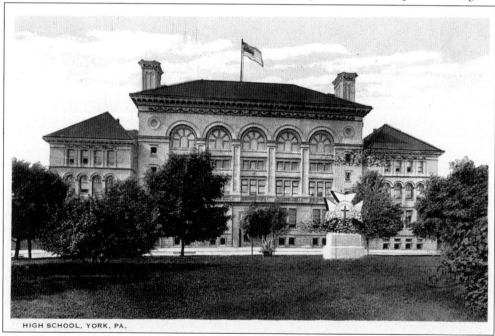

HIGH SCHOOL, YORK, PA.

Located across College Avenue from Penn Park stood the York High School, completed in 1899 at a cost of $170,000. This building replaced an earlier high school that had operated for 25 years on West Philadelphia Street. A new high school was constructed in 1927, and this building for many years was Hannah Penn Middle School.

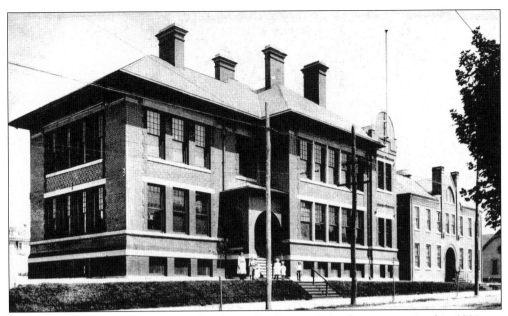

Designed by local architect B. F. Willis, the Ridge Avenue School was constructed in 1901 at a cost of $4,069. Between 1889 and 1907, a total of 13 schools were constructed in York, ranging in cost from $1,637 to $45,243. Although no longer a public school, the Ridge Avenue School building remains, as do other schools from the same period, including Central School on West King Street and Stevens School on West Philadelphia Street.

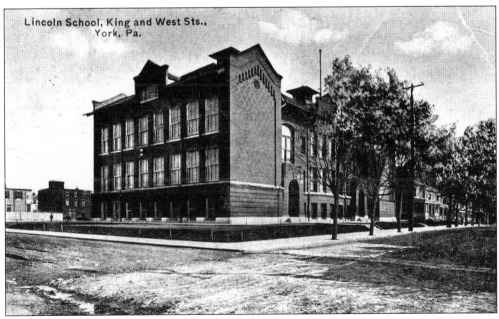

Lincoln School opened in 1909 and served the youth of York City until 1993, when a new modern Lincoln Elementary School was built.

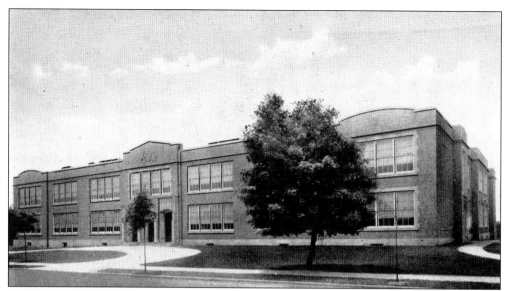

Constructed in 1931, this school is named for Phineas Davis, who built the first coal-burning locomotive. In 1831, the Baltimore & Ohio Railroad advertised a contest with a prize of $3,500 to see who could build the best coal- or coke-burning locomotive. Five engines entered the contest, and the *York* easily won. Shortly thereafter, Davis was hired as manager of shops for the railroad.

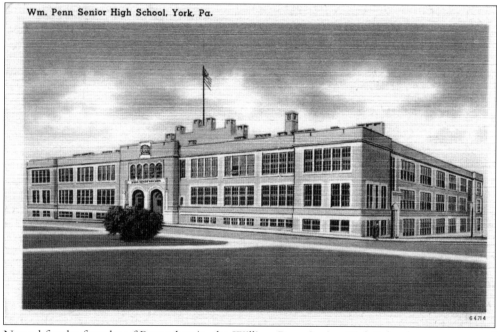

Wm. Penn Senior High School, York, Pa.

Named for the founder of Pennsylvania, the William Penn Senior High School was constructed in 1927 near Penn Park and the existing York High School on College Avenue. In 1940, an annex was constructed, and by 1945, more than 2,400 students attended classes here. Still in use, the school received a major renovation in 2004–2005.

Four
PUBLIC BUILDINGS

This chapter features buildings constructed by the government—the York County Court House, for instance—or buildings constructed by a third party that eventually became affiliated with the government. The firehouses are an example of the latter. Most fire companies were formed by citizens. Attractive engine houses were built, and eventually the companies became part of the York City Fire Department. The York County Court Houses have always been impressive structures for their day, from the first courthouse built during Colonial times to the towering York County Judicial Center built in the early 21st century. The York County government was responsible for several other buildings featured in this chapter, including the York County Almshouse, York County County Home, and York County Jail. Two York City Halls are also featured in postcards. Most Yorkers have no problem providing directions to the current city hall—after all, that is where they pay their parking tickets—but few know that city hall was once located on South Duke Street. Federal buildings in York are primarily postal facilities, which exhibit a high level of architectural design.

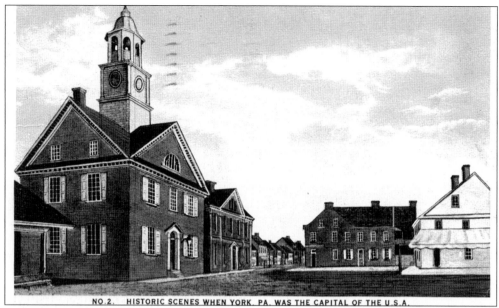

NO. 2. HISTORIC SCENES WHEN YORK. PA. WAS THE CAPITAL OF THE U.S.A.

This 1927 postcard is part of a series depicting York in the 1830s. The paintings were created by William Wagner, a local engraver. Today, a replica of the "Colonial Courthouse" sits on the bank of the Codorus Creek, but the original adjacent building was located in Centre (Continental) Square. Both the York County Court House and State House were demolished in 1841 after construction of a new courthouse on East Market Street.

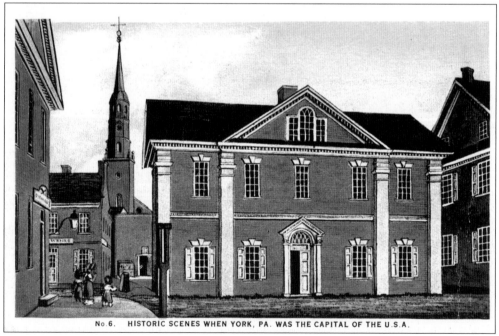

No. 6. HISTORIC SCENES WHEN YORK, PA. WAS THE CAPITAL OF THE U.S.A.

This vintage view of York Town was published in 1927 by the Conservation Society of York County as part of the 150th anniversary of York's tenure as capital of the United States. This building was known as the State House and stood adjacent to the York County Court House in Centre Square. Constructed in 1793, the building contained county government offices.

Designed by York's most notable architect, John Augustus Dempwolf, this building was the third York County Court House. It was constructed on the site of the second York County Courthouse, and Dempwolf reused the Ionic columns from that building. Until a 1957 renovation and expansion, the facade was of yellow brick.

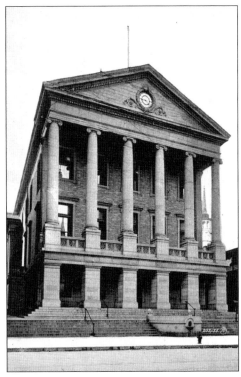

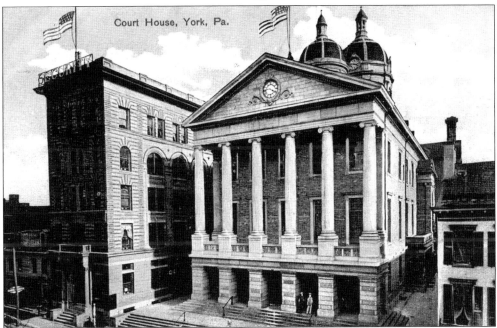

Here is another view of the York County Court House. Three domes inspired by the Florence Cathedral in Italy are perhaps the most notable feature of the building. The main dome reaches a height of 155 feet, and the smaller domes are 106 feet. The cost for the original building was $350,000. In 1957, the building was renovated and expanded, with wings added to the east and west.

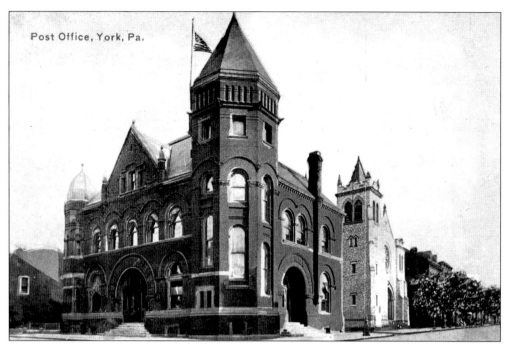

Post Office, York, Pa.

Constructed in 1895 on the northeast corner of Philadelphia and Beaver Streets, the "Federal Building" was built at a cost of $80,000. In addition to housing the post office, the U.S. Revenue Department was located on the second floor. Prior to the erection of this building, the York Post Office had been located at nine different sites.

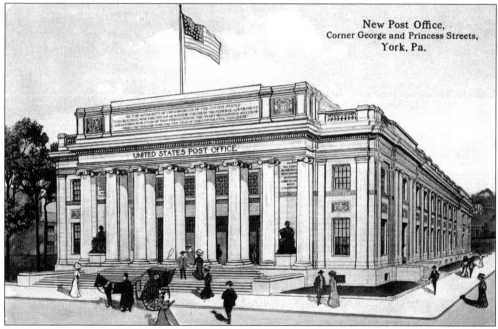

New Post Office,
Corner George and Princess Streets,
York, Pa.

A 1912 Act of Congress appropriated $135,000 for a new postal facility in York. Local Congressman Daniel F. Lafean was instrumental in securing the funds for this building, as well as appropriations for new postal facilities in Hanover and Gettysburg.

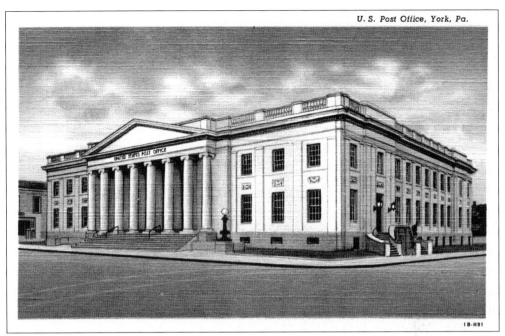

In commemoration of the Second Continental Congress's time in York, the York Post Office was expanded in 1940 at a cost of $1 million. In addition to serving as a postal facility, the building included offices of the Bureau of Internal Revenue, Social Security, and Army, Navy, and Marine Corps Services. Today, the building continues to function as a post office.

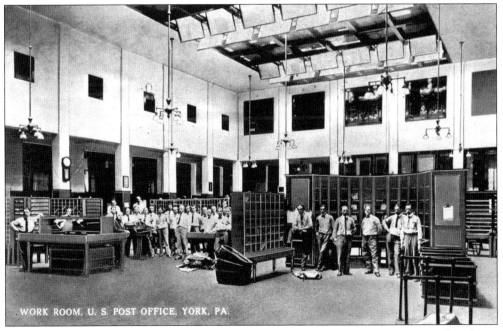

WORK ROOM, U. S. POST OFFICE, YORK, PA.

This postcard is one of only a few published in the early and mid-20th century that depict building interiors. York's first postmaster was Andrew Johnston, who was wounded in the American Revolution. He was appointed in 1790.

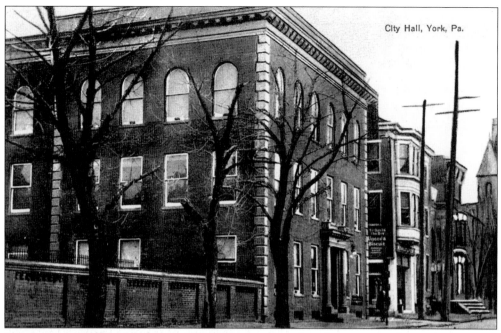

City Hall, York, Pa.

Incorporated in 1903, the Guardian Trust Company purchased property at the southeast corner of Market and Duke Streets for use as a bank. To the rear of the property stood a large stable, which was enlarged for use as city hall. Subsequently, Guardian Trust purchased an adjacent property and expanded city hall.

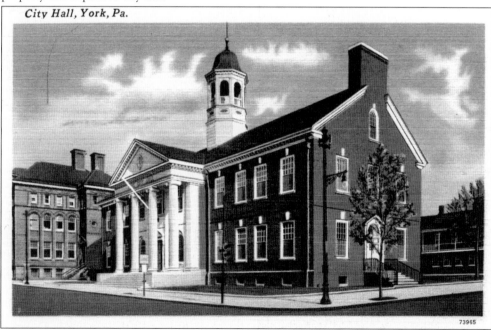

City Hall, York, Pa.

Constructed in 1941 at a cost of $225,000, the York City Hall was built in commemoration of York's 200th anniversary. The symbolic building was dedicated on May 30, 1942. The lobby was patterned after Independence Hall in Philadelphia, and the cupola is said to have been inspired by the one that stood atop the original York County Court House in Centre Square.

50

Originally known as the Union Fire Company, this company was organized *c.* 1780. It changed its name to the York Vigilant Fire Company in 1816. Some 55 years later, a new firehouse was constructed at a cost of $7,199 and a 2,200-pound alarm bell was purchased. Horse service was introduced in 1887. Sadly, this building was demolished in 1973.

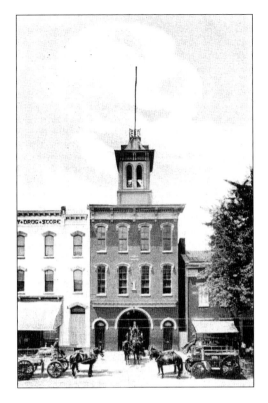

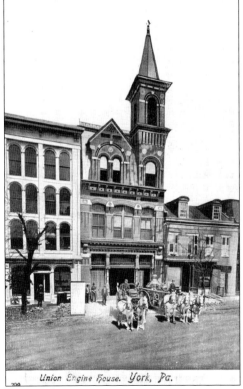

Union Engine House. York, Pa.

Dr. Alexander Small of the Small & Smyser Iron Works was instrumental in organizing the Union Fire Company. An engine house was built in 1855 and used until this handsome facility was constructed at 141 North George Street in 1884. In 1970, the building was judged unsafe and was vacated. Eventually, it was demolished. Several years later the Union and Vigilant Companies consolidated in a new building on West Market Street.

51

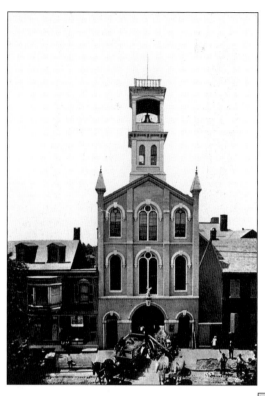

The Rescue Steam Fire Engine and Hose Company was organized in 1872 to serve the southern portions of York. A cooper shop was rented to serve as the engine house, and this South George Street facility was dedicated in 1874. Unlike the Union and Vigilant stations constructed during the Victorian era, this building is still standing. It originally had two bays for apparatus, but they were subsequently combined into a single, larger bay.

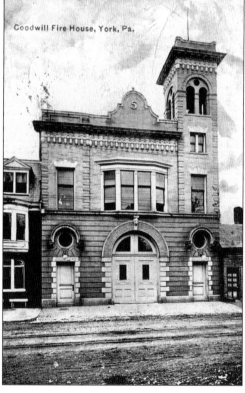

The Springgarden Active Fire Company was founded in 1839 in the village of Freystown. The company changed its name to Goodwill Fire Company in 1852 and constructed a new facility in 1858. Freystown residents voted to become part of the borough of York in 1890, although the fire company did not join the York Fire Department until 1900. The current engine house, pictured here and still in use, was constructed in 1902.

The Laurel Fire Company had its beginnings in the early 1770s, making it one of the oldest fire companies in America. Originally known as the Sun Fire Brigade of Yorktowne, it had a laurel wreath as part of its seal by 1772. Even the Second Continental Congress recognized the "fire company of Yorktown having on its engine a laurel wreath." This beautiful Italianate building was constructed in 1878 and was expanded a decade later.

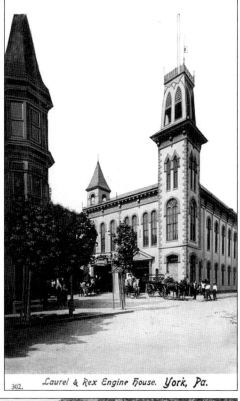

302. Laurel & Rex Engine House. York, Pa.

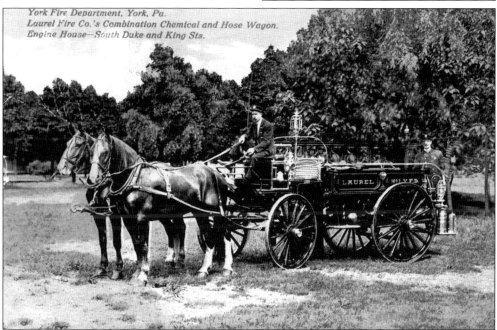

York Fire Department, York, Pa.
Laurel Fire Co.'s Combination Chemical and Hose Wagon.
Engine House—South Duke and King Sts.

The Laurel Fire Company introduced horse service in 1886 with the acquisition of a pair of bay horses, Harry and Frank, and the renovation of its engine house to accommodate stables. The company's first chemical engine was purchased in the 1890s.

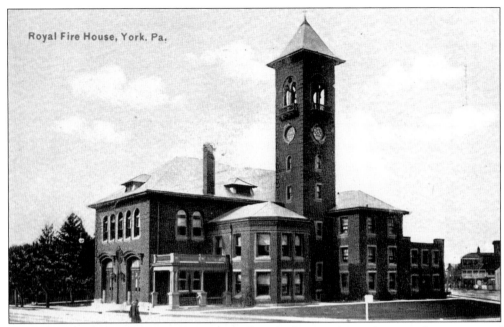

Royal Fire House, York, Pa.

Organized in 1901 to serve the western part of York, the Royal Fire Company became part of the York Fire Department in 1902 and constructed this striking Romanesque facility a year later. No longer in use as a firehouse, this building now pays homage to its past as the home of the Fire Museum of York County.

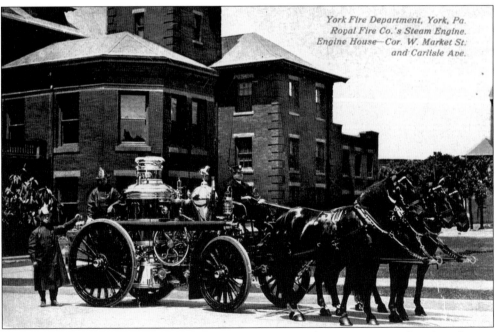

York Fire Department, York, Pa.
Royal Fire Co.'s Steam Engine.
Engine House—Cor. W. Market St.
and Carlisle Ave.

The Royal Fire Company's first apparatus was a borrowed wagon equipped with only two portable fire extinguishers. The company's first steam engine was ordered in 1903 from the Manchester Locomotive Works (New Hampshire), which delivered it in 1904.

The Reliance Fire Company was organized in 1904 in West York. An engine house was constructed one year later at a cost of $2,200.

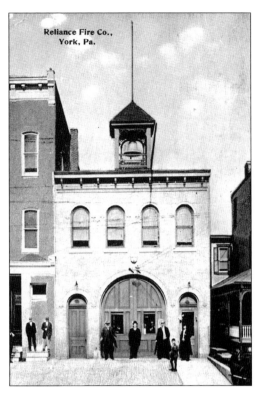

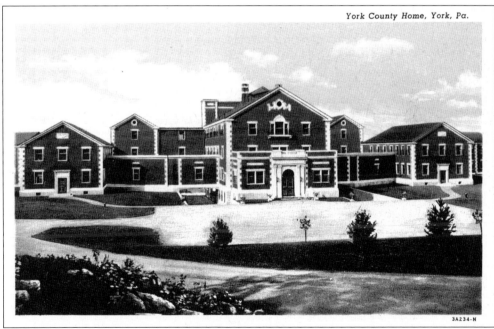

The York County Home was located several miles east of York City at the site of the present-day Pleasant Acres complex. The building was constructed in 1931 at a cost of approximately $1 million. Residents of the facility farmed the adjacent land, which at one time consisted of 100 acres.

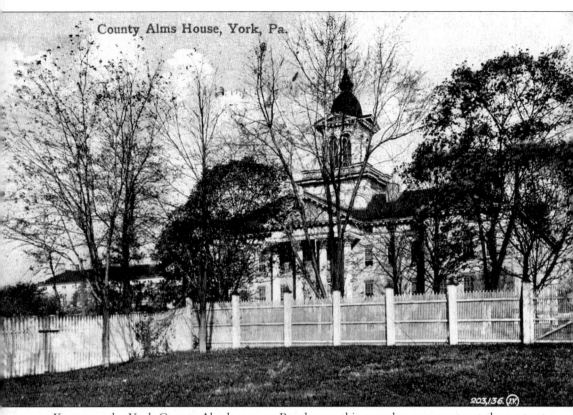
County Alms House, York, Pa.

Known as the York County Almshouse, or Poorhouse, this complex was constructed on a tract of land known as Elm Springs Farm. The first structures were built in 1805, with a hospital building constructed in 1828. Residents of the poorhouse helped construct the hospital building and also farmed the land.

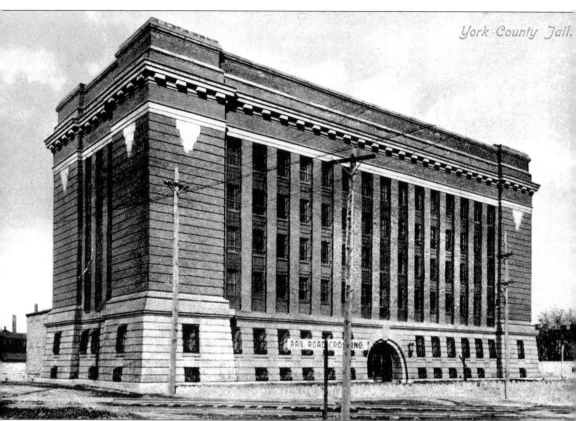

York's original jail was located at George and King Streets. The prominent location was deemed inappropriate, however, and a new facility was built near the York County Almshouse in 1854. The main building, which had a castlelike appearance, was demolished in the early 20th century to make way for the building featured in this postcard. This jail operated until 1979, when a large new facility was constructed east of York City.

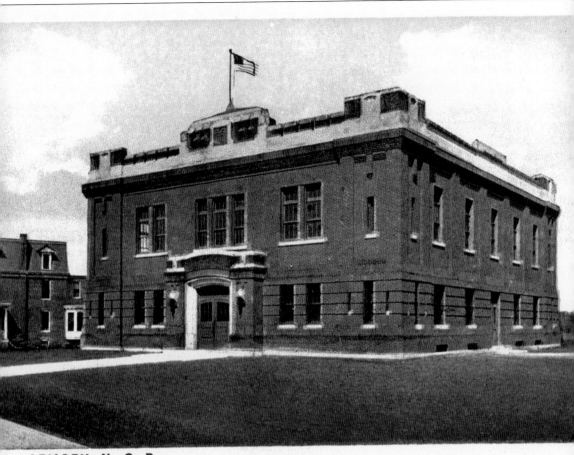

ARMORY, N. G. P.

The York Armory of the Pennsylvania National Guard was constructed in 1913 along North George Street, adjacent to the Codorus Creek. It was built for Company A and Company K of the 8th Infantry. A drill hall was located on the second floor. Today, the building is listed on the National Register of Historic Places.

Five

AROUND YORK

From markets to mansions, train stations to theaters, the scenes on postcards of the early and mid-20th century portray a snapshot of a bygone era. They also indicate what Yorkers thought was important: theaters for entertainment, farmers' markets for sustenance, and clubs to gather with like-minded neighbors. Some of York's prominent business leaders and politicians even found images of their homes on postcards. This section has a heavy emphasis on York City, although there are a number of postcards from beyond city limits. These images demonstrate the growing importance of the suburbs and also portend the decline of the importance of the downtown. For example, the Small mansion, located in Spring Garden Township, is an early example of wealthy business leaders moving outside of the city. Likewise, the York Motor Club was located in East York, a suburban neighborhood that owes much of its existence to the automobile.

The City Market House is one of the most architecturally significant buildings ever to grace
York's cityscape and demonstrates a High-Victorian-Gothic architectural style no longer found
in York. The original building was constructed in 1878 and was expanded several times. The

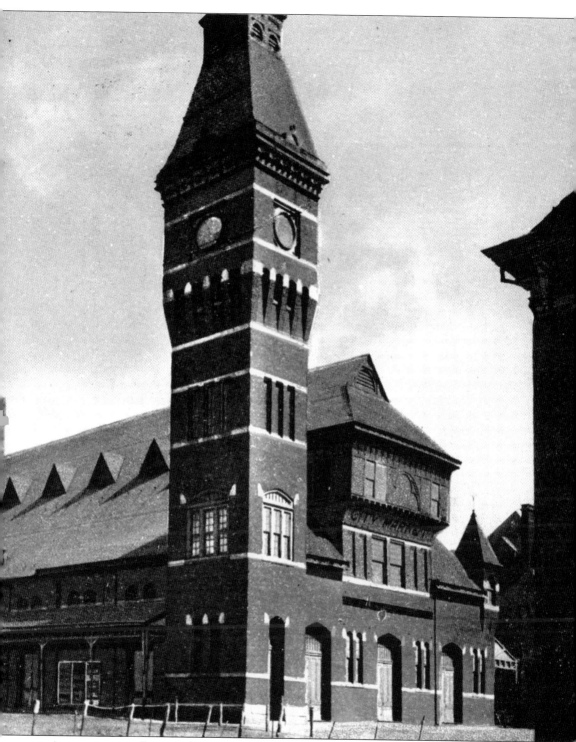

prominent tower stood at 140 feet. Unfortunately, the Duke Street market was demolished in 1963 to make way for a gas station.

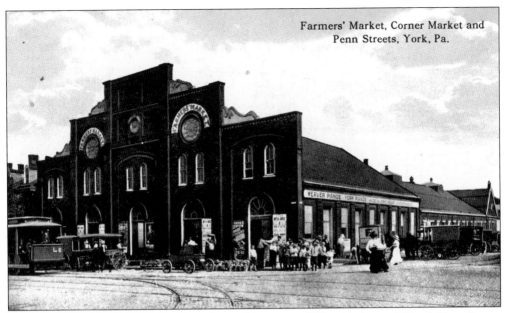

Farmers' Market, Corner Market and
Penn Streets, York, Pa.

Operating since 1866, the Farmers' Market at the corner of West Market and North Penn Streets is the oldest continuously operating market in York. Farmers' markets have long been a local tradition. At one time five markets operated within city limits: Farmers' Market, City Market on South Duke Street (1879), Eastern Market on East Market Street (1885), Central Market on Philadelphia Street (1888), and the Carlisle Avenue Market and Storage Company (1902).

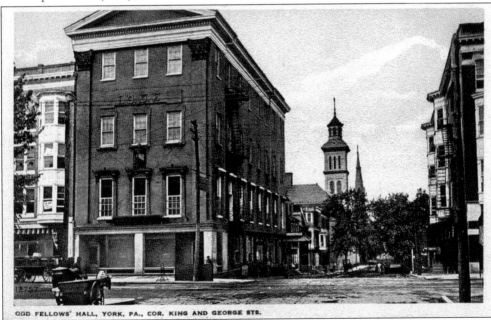

ODD FELLOWS' HALL, YORK, PA., COR. KING AND GEORGE STS.

The Odd Fellows Hall on South George Street was built in 1850. During the Civil War, it served as barracks for troops training at the fairgrounds, as well as a backup to the U.S. Army Hospital in Penn Park. The local Odd Fellows lodges were instrumental in creating a public library, housed in this building. Washington Hall, a theater on the second floor of the building, served as a venue for music and drama.

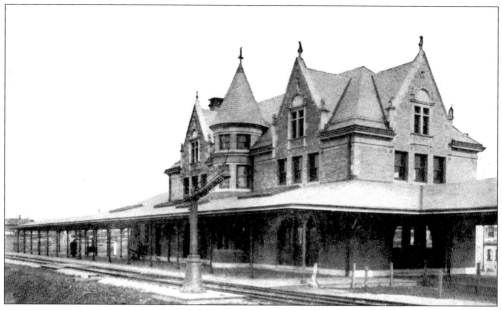

Western Maryland Railroad arrived in York in 1893, giving local manufacturers access to the international market via Port Covington in Baltimore. Two buildings were constructed along North George Street at the Codorus Creek. A freight station and attached business office was built on the west side of George Street and still stands today. The handsome passenger station, located across the street, employed a French Chateau style of architecture.

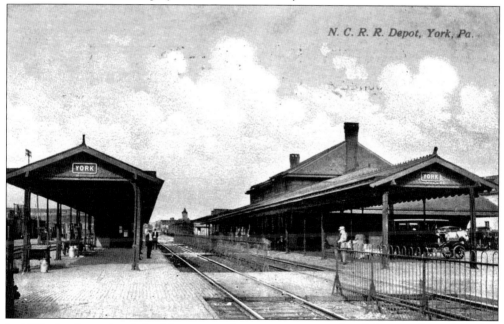

In 1832, the Pennsylvania Legislature passed an act to create a railroad from York southward to the Maryland line and eastward to Wrightsville. Six years later the line between York and Maryland was completed, although the Wrightsville line was not finished until 1843. Several railroad companies controlled various sections and, in 1854, consolidated as the Northern Central Railroad. This passenger station, which still stands, was constructed in 1890.

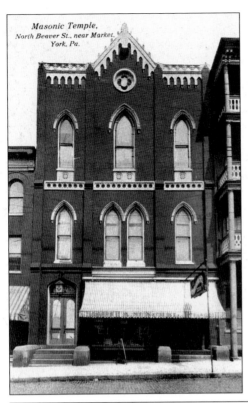

Masonic Temple,
North Beaver St., near Market,
York, Pa.

York's original Masonic Hall was constructed in 1863 on North Beaver Street, adjacent to the National Hotel. Frederick Stallman, owner of the hotel, was an active Mason and built the hall.

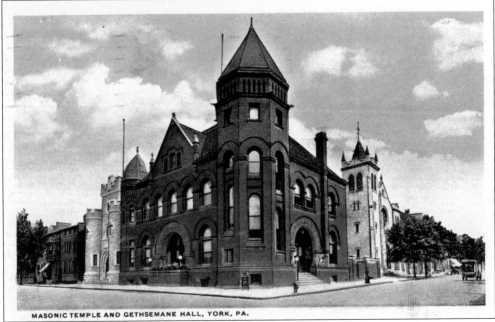

MASONIC TEMPLE AND GETHSEMANE HALL, YORK, PA.

Almost 50 years after construction of the original Masonic Temple, the old post office building less than a block away was purchased and the temple relocated. In 1912, Gethsemane Hall was constructed next door to accommodate even larger groups. The hall is unique in York for its castlelike appearance.

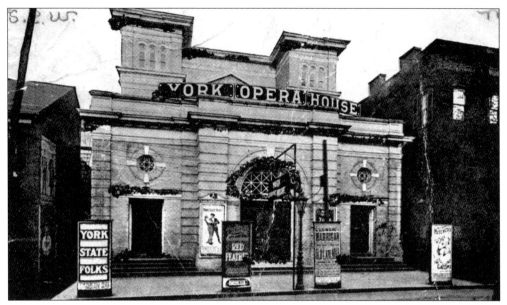

Built at a cost of $38,000, the York Opera House opened to crowds in 1881. Opening night featured comedian John S. Clark in *Toodles*. The building proved a popular attraction and was renovated in 1892. In 1897, the York Opera House became the first place in York to show moving pictures. Tickets for the silent, flickering movies ranged from 15¢ to 25¢. One of the first movies to be shown was *A Newark Fire Company Answering a Call*. The crowd pleaser featured engine horses galloping down a street. The York Opera House proved to be such a popular destination that it was expanded in 1902.

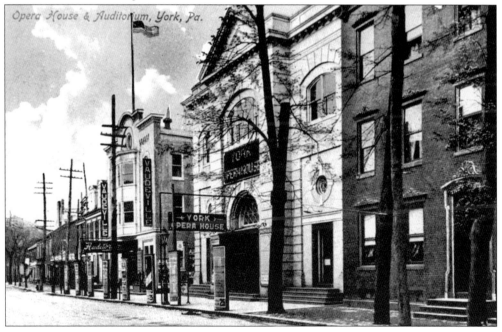

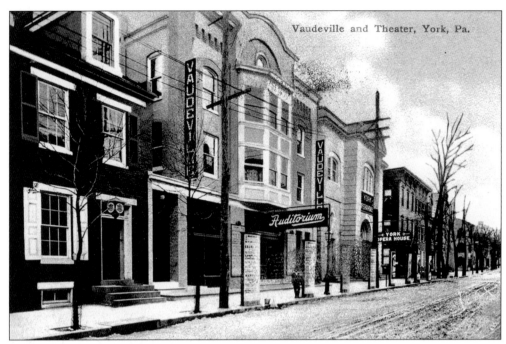

Vaudeville and Theater, York, Pa.

The Auditorium (Orpheum) on South Beaver Street, Hippodrome on West Market Street, Jackson Theater on North George Street, and Mystic Theater on North George Street were popular destinations for live performances and moving pictures in the early 20th century.

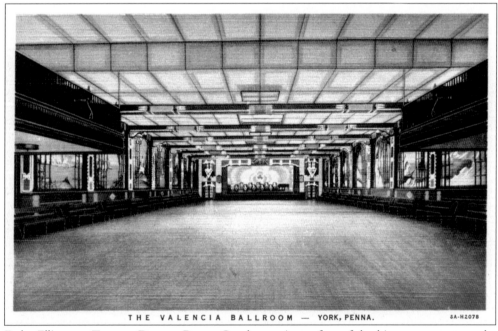

THE VALENCIA BALLROOM — YORK, PENNA.

Duke Ellington, Tommy Dorsey, Benny Goodman—just a few of the big-name acts to make appearances at the Valencia Ballroom. Constructed in 1911 as the Coliseum Ballroom, the building was remodeled in the 1930s. The Blue Moon Orchestra was the house band and played to large crowds; the major acts would pack in as many as 2,000 people.

Constructed in the 1860s, this prominent townhouse became home to York Lodge No. 213 of the Benevolent and Protective Order of Elks in 1904. Founded in 1891, the York Elks organization eventually added a ballroom, card room, and bowling alley to its lodge.

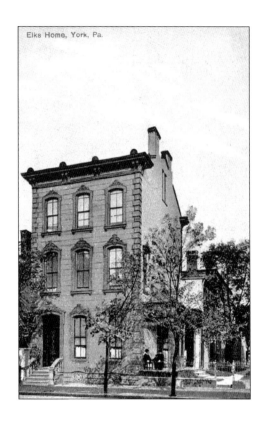

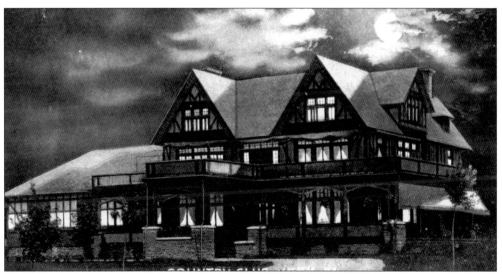

York's first golf course was created in 1885 at the estate of Grier Hersh. Hersh introduced many Yorkers to golf, including A. B. Farquhar, a prominent industrialist. Farquhar was captivated by the sport, and he and Hersh set out to create a new golf course in 1890. They obtained 67 acres of land and constructed a clubhouse and a nine-hole golf course, which is today the site of York College of Pennsylvania.

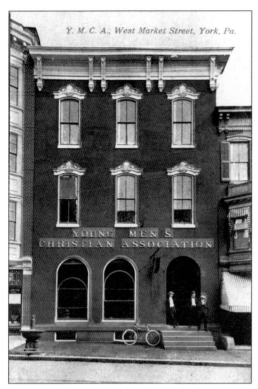

Y. M. C. A., West Market Street, York, Pa.

The Young Men's Christian Association (YMCA) informally reached York in 1855 via affiliations with local churches. In 1869, the organization was formalized. Meetings were held at firehouses and other places until a property on the 100 block of West Market Street was purchased in 1884. Within four years the facility housed a gymnasium, auditorium, and swimming pool. Subsequently, an adjacent building was purchased, and the YMCA remained here until well into the 1920s.

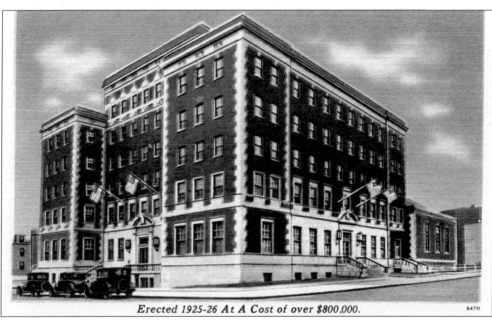

Erected 1925-26 At A Cost of over $800,000.

The YMCA was constructed at the southwest corner of West Philadelphia and North Newberry Streets in 1926 at a cost of $856,000. Most of the funds for the building came from a campaign that was launched in 1922 and raised almost $600,000. The YMCA Ladies Auxiliary contributed in excess of $50,000 for the project. The building originally contained 158 dormitory rooms, as well an array of physical fitness facilities.

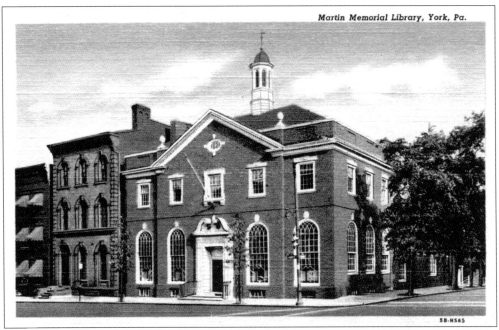

Martin Memorial Library was made possible by a gift from Milton Martin, a business leader who died in 1912. In his will he left $125,000 for the creation of a library and $60,000 to establish a fund for library maintenance. Property was purchased in 1920 on the northwest corner of East Market and Queen Streets, and the library was constructed in 1935 after enough funds had been raised.

The Historical Society of York County was founded in 1895. Members originally met on the third floor of the York County Courthouse. While the organization was growing, J. W. Richley started a bicycle business, eventually expanding into an automobile dealership and constructing this building on East Market Street in 1921. The Historical Society of York County later purchased and renovated the building for its new home. The organization thrives today and is now the York County Heritage Trust.

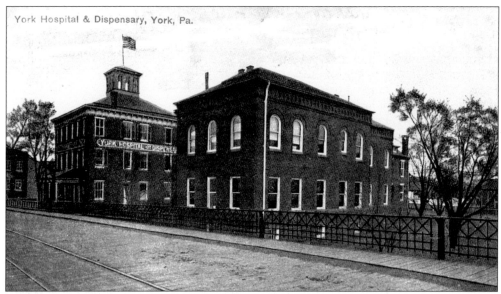

The York Hospital and Dispensary was incorporated in 1880 by the York County Medical Society. Its first location was an building purchased by local philanthropist Samuel Small and donated for use as a hospital. In the early 1900s, a larger facility was constructed on the same site.

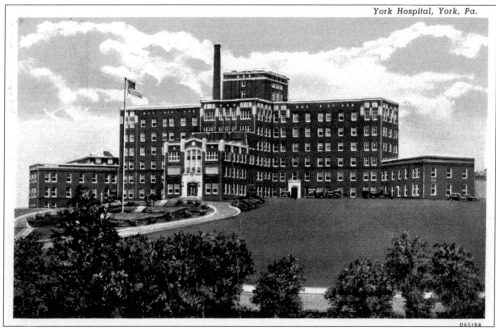

York Hospital, York, Pa.

The York Hospital and Dispensary changed its name to York Hospital in 1925 and constructed this building in 1929–1930 at a cost of approximately $1 million. In the 1950s, a new wing was added. The hospital has undergone many renovations and expansions, becoming one of the largest healthcare facilities in the region.

Daniel F. Lafean was a prominent local businessman in York in the late 19th century and was elected to represent York and Adams Counties in Congress. Through his efforts funding for new postal facilities in York, Hanover, and Gettysburg was obtained. His attractive residence was located on West Market Street at Richland Avenue.

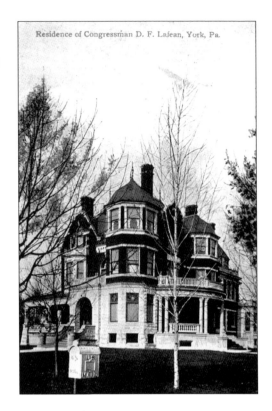

Residence of Congressman D. F. Lafean, York, Pa.

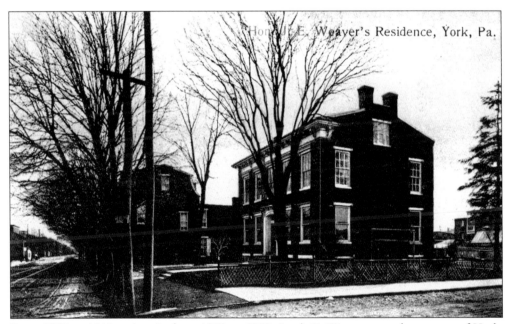

Hon. J. E. Weaver's Residence, York, Pa.

From 1908 to 1911 and again from 1928 to 1932, Jacob E. Weaver served as mayor of York. Weaver was a stenographer for 10 years and, in 1904, was admitted to practice law. He also served as notary public to several banks and was a member of the Masonic Order, Odd Fellows, and Vigilant Fire Company.

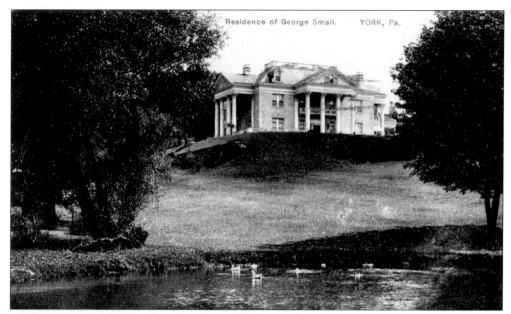

Residence of George Small. YORK, Pa.

This estate, known as Lower Grantley, was the home of George Small. The first Grantley estate was constructed on a hill south of York in 1878 by another member of the Small family, whose wife's maiden name was Grant. Grantley, Brockie, Edgecombe, Rural Felicity, and Springdale were a few of the large estates constructed in the 19th and early 20th centuries on the southern edge of York City.

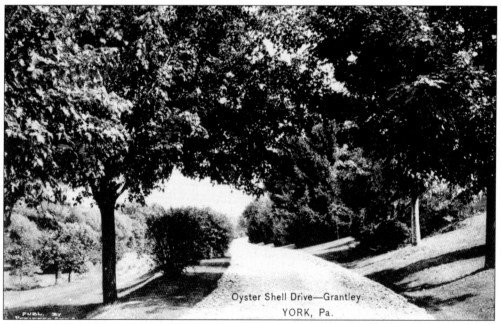

Oyster Shell Drive—Grantley.
YORK, Pa.

Oysters have been a popular food for Yorkers since the Colonial period, when they were brought by the wagonload from the Chesapeake Bay. Alleys and other roads were paved with pulverized oyster shell; in fact, many city residents doing gardening work or excavations in their backyards have come across buried oyster shells.

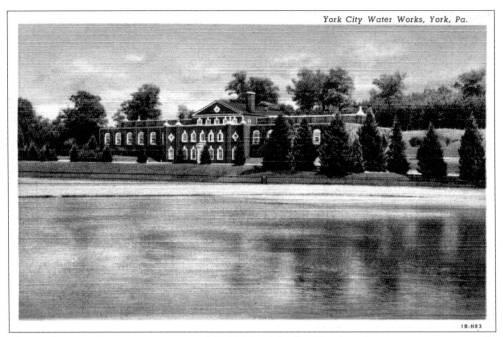

1B-H83

The York Water Company was created in 1816, originally using log pipes to transport water. In 1840, the company began using cast-iron pipes. A sand filter plant was constructed in 1899 and a larger, more modern plant in 1932. The York City Water Works sit atop Reservoir Hill.

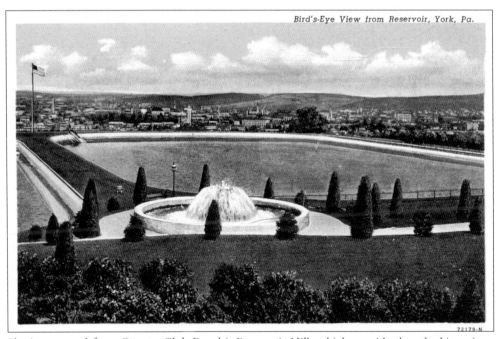

Bird's-Eye View from Reservoir, York, Pa.

72179-N

Sloping upward from County Club Road is Reservoir Hill, which provides breathtaking views of York. This postcard view showcases how the city is situated among the gentle rolling hills of York County.

73

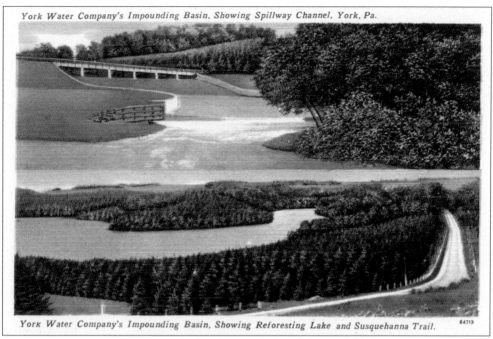

York Water Company's Impounding Basin, Showing Spillway Channel, York, Pa.

York Water Company's Impounding Basin, Showing Reforesting Lake and Susquehanna Trail. 64713

A major drought in 1910 was the impetus for construction of a new impounding basin in 1913. Known as Lake Williams, the basin in 1945 held over 900 million gallons. The York Water Company was a leader in reforestation, planting over 1.25 million trees in the area.

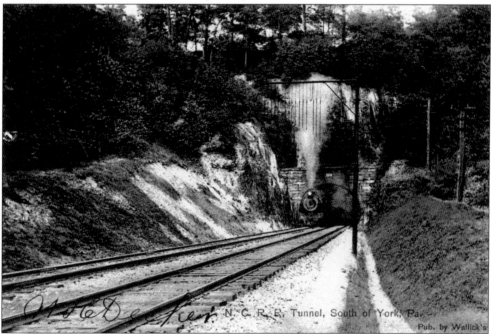

N. C. R. R. Tunnel, South of York, Pa.

Pub. by Wallick's

The Howard Tunnel is one of the oldest continuously operating railroad tunnels in the world. It was built in 1840, cutting through 300 feet of solid rock. During the Civil War, the Pennsylvania militia guarded the tunnel from Confederate raiders, as the railroad was vital to the Union effort, transporting soldiers and supplies from the North and West.

74

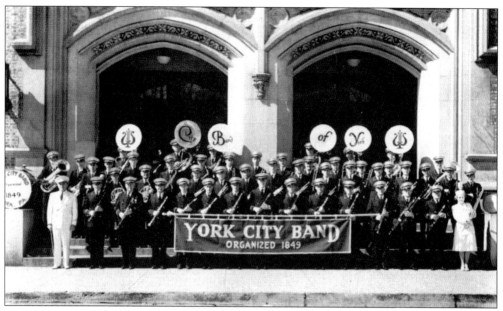

The York City Band was founded in 1849 as the Worth Infantry Band. Membership was limited to 45, and auditions were required to become a member. For decades the York City Band was the highlight of parades, rallies, and summer concerts in the parks in and around York City.

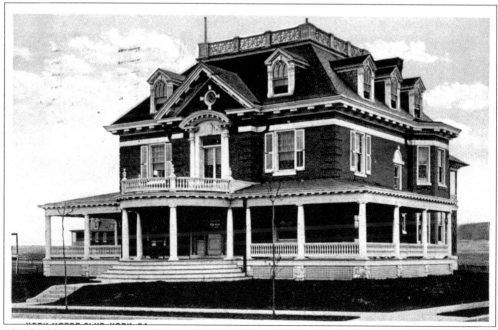

This building was constructed as a private residence in East York, but a tragedy prevented the family from moving in. The York Motor Club purchased the empty home and opened up business, lasting here for only a few years. The Colonial Revival building then became a private residence. It still stands today.

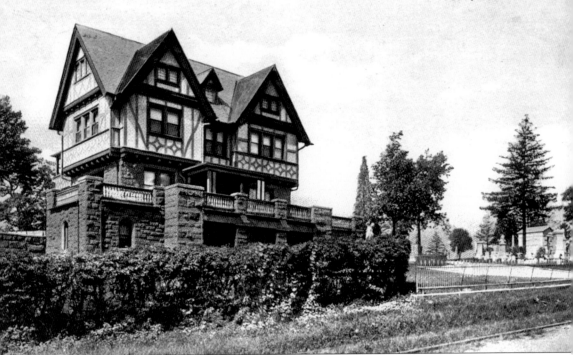

Prospect Hill Cemetery was created by York's First Reformed Church in 1849. Several downtown churches relocated their cemeteries here, including the Moravian Cemetery, which was moved here in 1908. Several hundred Civil War soldiers are buried here, and Soldiers Circle is a monument to all who fought in the war. Phillip Livingston, a signer of the Declaration of Independence and New York delegate to the Second Continental Congress, died while in York and is buried here.

Six

STREETSCAPES

The streetscapes of York tell the story of a dynamic community that is constantly changing. They not only show what has sadly been lost to progress but also reveal how many of York's architectural treasures remain today. The York Historic District, listed on the National Register of Historical Places, encompasses most of the downtown and is one of the largest urban historic districts in the Commonwealth of Pennsylvania. In fact, several thousand buildings contribute to the district. Many of the streetscape postcards also reveal residential areas and suburbs. While development continued in the downtown, Market Street became more residential farther away from Centre Square. York's first streetcar suburb, the Avenues, or Northwest York, was laid out in the 1880s. The beautiful old homes of yesteryear are still highly attractive to buyers today.

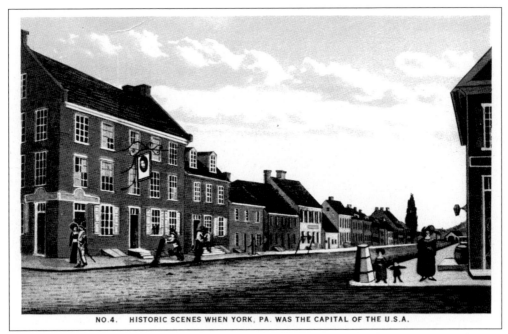

NO. 4. HISTORIC SCENES WHEN YORK, PA. WAS THE CAPITAL OF THE U.S.A.

This early-19th-century view is another of the postcards published by the Conservation Society of York in 1927. The view is of the south side of West Market Street's 100 block. The large building to the left housed the Hall & Seller's Press—once owned by Benjamin Franklin—while the Second Continental Congress met in York. In 1912, the Bon-Ton Department Store constructed a major new building on this site.

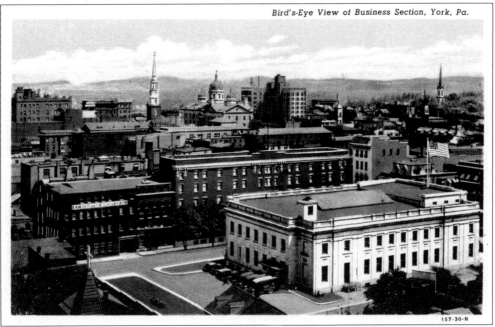

Bird's-Eye View of Business Section, York, Pa.

The large building in the foreground of this bird's-eye view is the York Post Office, prior to expansion. The domes of the York County Courthouse are flanked by the Christ Lutheran Church steeple (left) and Yorktowne Hotel (right).

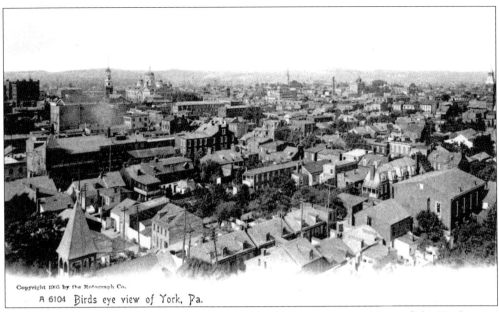

A 6104 Birds eye view of York, Pa.

This early-20th-century view shows York's skyline prior to construction of the Yorktowne Hotel. The tower on the far right is the York City Market on South Duke Street.

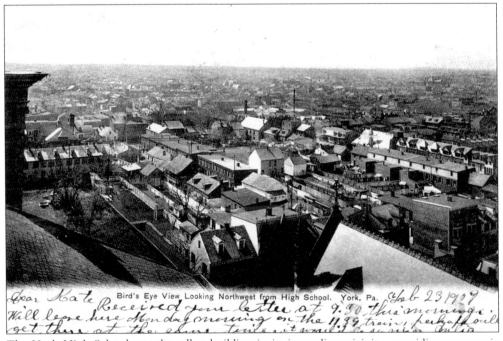

Bird's Eye View Looking Northwest from High School. York, Pa.

The York High School was the tallest building in its immediate vicinity, providing panoramic views from the roof. The western part of York City is showcased in this bird's-eye view.

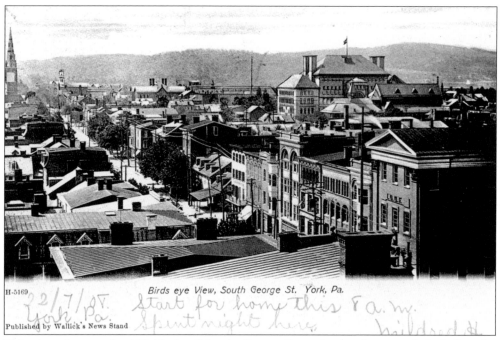

Birds eye View, South George St. York, Pa.

H-5169

Published by Wallick's News Stand

This view features the 100 block of South George Street in the foreground, including the Odd Fellows Hall, as well as the York High School in the distance. The tower to the left is St. Mary's Church.

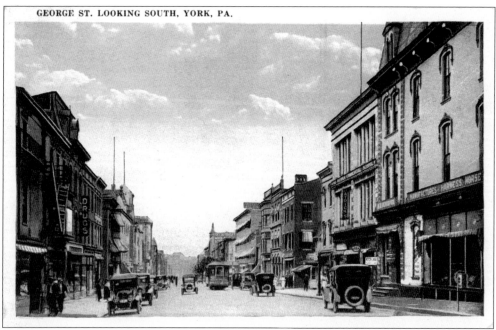

GEORGE ST. LOOKING SOUTH, YORK, PA.

This view showcases the first block of North George Street in the early 1920s. The building on the far right is the Spahr Building, demolished *c.* 1923. The large building to the right of the trolley car is Hotel Penn, site of the present-day York County Judicial Center.

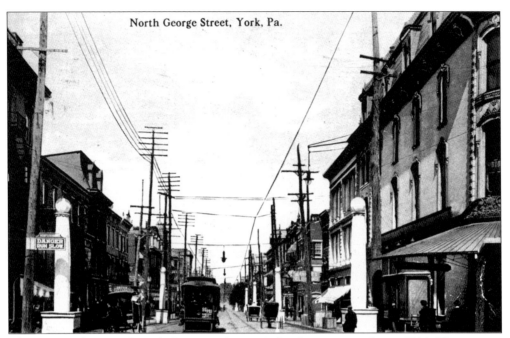

North George Street, York, Pa.

These postcard views of North George and East Market Streets were taken *c.* 1911. They present very similar views of York in the early 20th century: monuments lining the streets, horse-drawn buggies, and trolley cars.

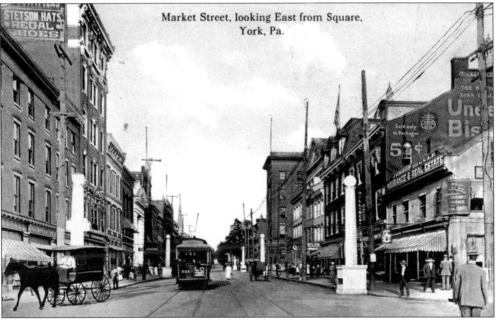

Market Street, looking East from Square, York, Pa.

The west side of the first block of South George Street has greatly changed over the years. The Colonial Hotel, on the right side of the image, still stands, but the rest of the buildings pictured here are long gone. Today, 96 South George Street, a large, modern office building, stands on this spot.

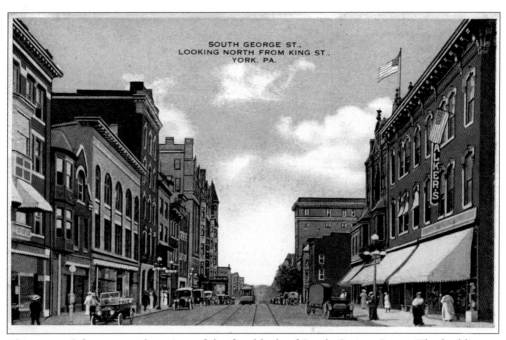

This postcard features another view of the first block of South George Street. The building to the right was constructed c. 1915 on the site of York's first jail.

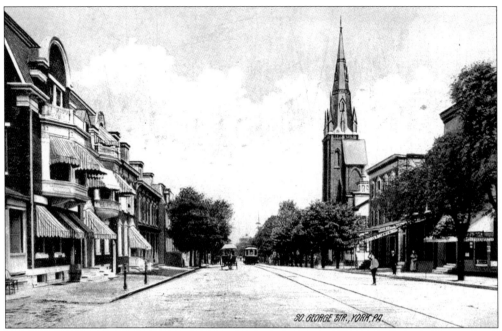

This view of the 300 block of South George Street showcases how just a few blocks from Centre Square the main north–south thoroughfare became mostly residential in nature. The large church is St. Mary's Roman Catholic Church. This view is looking northward toward the downtown.

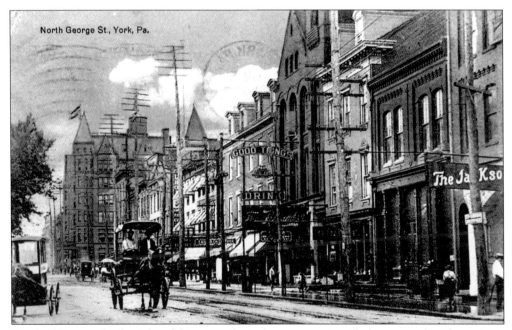

The building on the far right of this view, the Jackson, was originally known as the Theatorium. It was eventually extensively remodeled into the Capital Theater in 1917. The two buildings next door were razed to make way for the Strand Theater, which was completed in 1925. The brick building with the "Good Things Drink" sign was home to Lehmeyer Brothers, a prominent clothing store that operated until 1974.

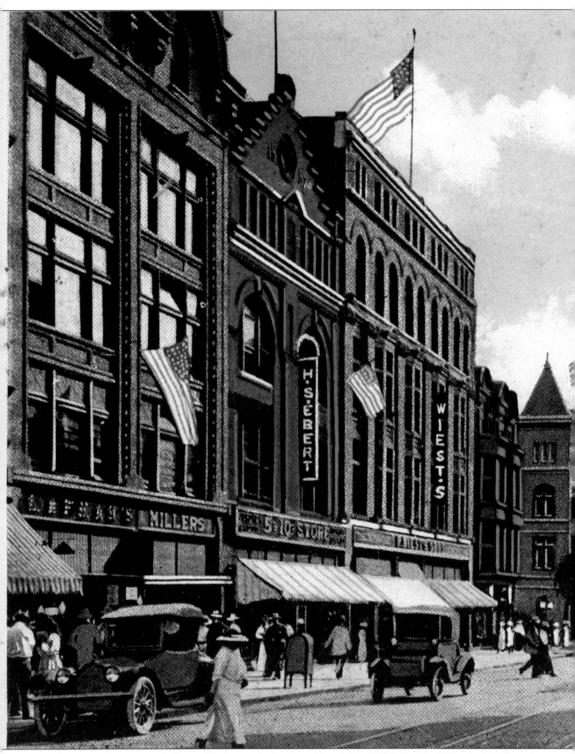

This attractive postcard shows York as a hub of retail activity. With Bear's, Wiest's, McCrory's, and Woolworth's clustered nearby, and the Bon-Ton Department Store less than a block away,

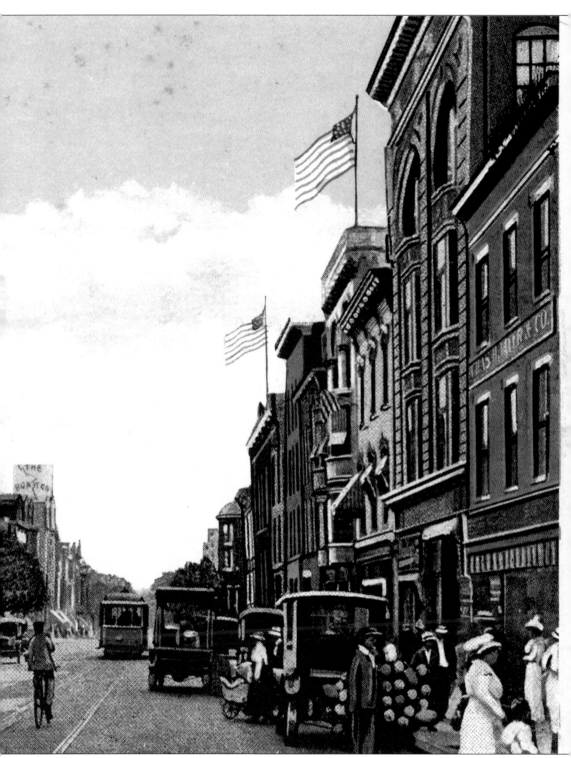

the first blocks of West Market Street were a major shopping destination during much of the 20th century.

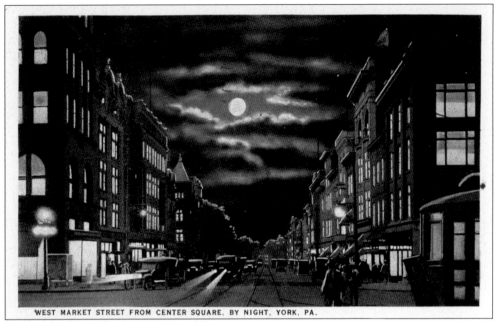

WEST MARKET STREET FROM CENTER SQUARE, BY NIGHT, YORK, PA.

This night view demonstrates that York did not close up after the sun went down; rather, shopping venues remained open for the after-work crowd.

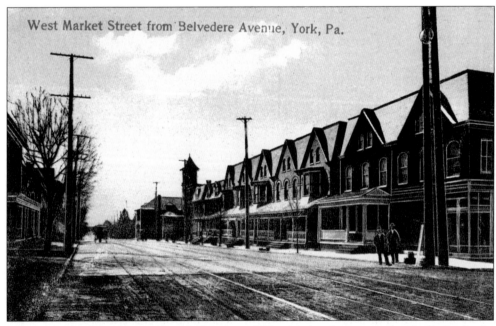

West Market Street from Belvedere Avenue, York, Pa.

This postcard exhibits the residential character of West Market Street near the city limits. In the distance the Royal Fire Company is visible. Prior to becoming part of York City, this area was known as Bottstown.

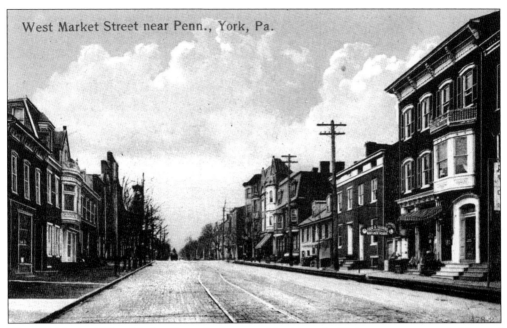

West Market Street near Penn., York, Pa.

The 300 block of West Market Street is showcased in this early-20th-century postcard. Many of these buildings still stand today, including the Market & Penn Farmers' Market, visible on the left side of the street.

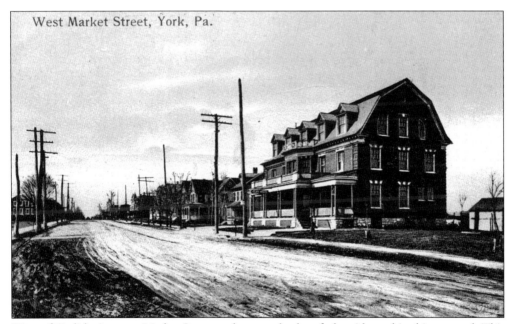

West Market Street, York, Pa.

West of Carlisle Avenue, Market Street took on a suburban feel, evidenced in this postcard. This building was greatly renovated and expanded as West Side Osteopathic Hospital, the forerunner of York Memorial Hospital.

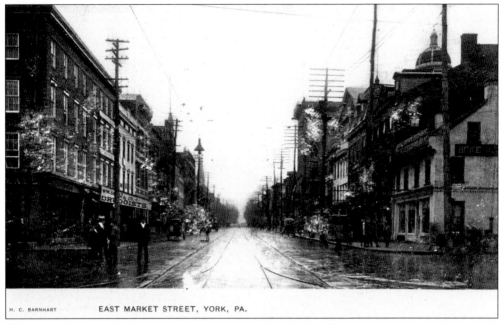

EAST MARKET STREET, YORK, PA.

This postcard is an early-20th-century view of the first block of East Market Street. The P. A. & S. Small Building is to the left, and the Golden Swan Tavern, or Weiser Building, is to the right.

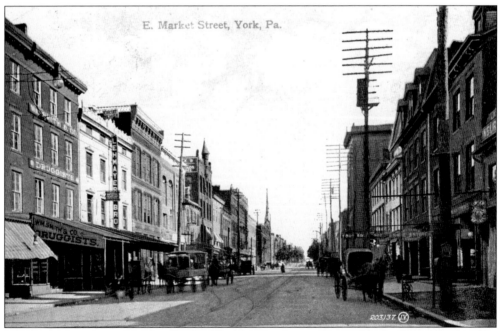

E. Market Street, York, Pa.

Here is another view of the first block of East Market Street. None of the buildings on the right side of the postcard remains today. W. M. Smith & Company Druggists and Lehmayer Brothers are notable businesses to the left. Lehmayer's later occupied a larger building on the same site and eventually relocated to North George Street.

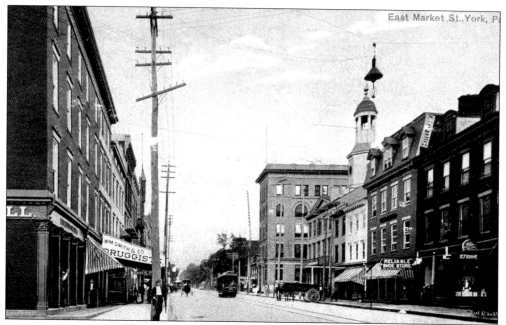

The most notable building in this view is the second York County Court House, built in 1841. The large tower to the right is part of the courthouse, which was replaced in 1898.

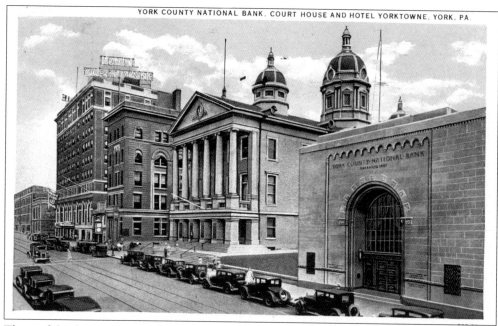

YORK COUNTY NATIONAL BANK, COURT HOUSE AND HOTEL YORKTOWNE, YORK, PA.

Three of the four buildings in this East Market Street postcard remain today. The York County National Bank building, on the right, received a concrete facade in the 1960s. The York County Courthouse was expanded in 1958. To the left of the courthouse is the Security & Title Company building, which was demolished during the courthouse expansion. The Yorktowne Hotel, on the far left, is the only building essentially unchanged today.

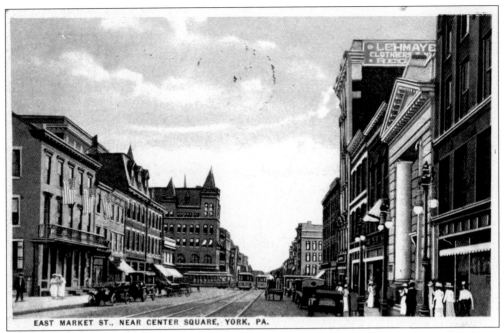

EAST MARKET ST., NEAR CENTER SQUARE, YORK, PA.

This view was taken east of Centre Square at the approximate location of the East Market Street Parking Garage that stands today. The Rupp Building is visible on Centre Square. Note the second building on the right side, featuring a pediment and columns. This is the York Trust Company Building, constructed in 1910.

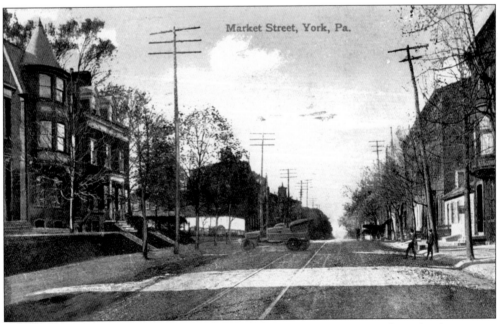

Market Street, York, Pa.

This Market Street view shows the different character of the street away from the downtown. Trolley tracks are visible, sharing the road with automobiles.

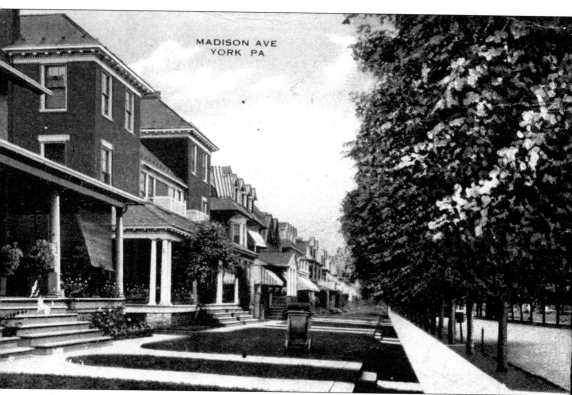

Madison Avenue was laid out between Farquhar Park and Carlisle Avenue in an area appropriately called the Avenues. This streetcar suburb was served by trolleys until the late 1930s.

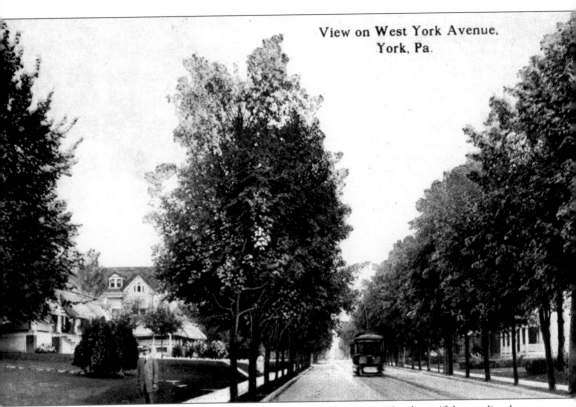

View on West York Avenue,
York, Pa.

West York Avenue is known today as Roosevelt Avenue. The beautiful tree-lined street with large single-family homes was attractive to many business leaders, who settled in this streetcar suburb.

Seven

PARKS

Penn Park, Farquhar Park, Highland Park—these "pleasure resorts" were major attractions around the beginning of the 20th century. Fountains, monuments, bandstands, and landscaped walkways defined Penn and Farquhar Parks. Most of the amenities in these parks were donated by local businesses and community groups. In many ways these postcard views exhibit an idyllic setting that no longer exists, particularly with regard to Penn Park. Highland Park was created by the York Street Railway Company, and its fast growth was due to the popularity of trolleys. It began as a Victorian picnic park and grew into a full-fledged amusement park, popular with Yorkers, as well as residents of places as far away as Baltimore—a train ride and short trolley ride away.

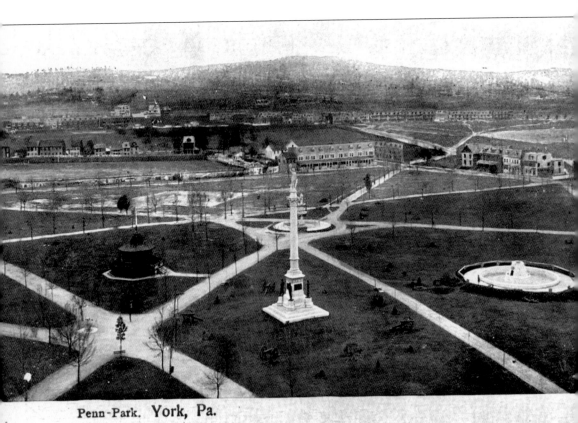

Penn-Park. York, Pa.

Penn Common, or Penn Park, has been an important part of York since the 18th century. During the American Revolution, troops trained here. After the Civil War began, a major U.S. Army Hospital was built here, which could house up to 1,000 wounded soldiers at a time. More than 14,000 Union and Confederate soldiers were treated here, including some 1,000 after the Battle of Gettysburg. Penn Common became Penn Park after local industrialist A. B. Farquhar gave $1,400 in 1890 for improvements to the grounds, including the laying out of walkways and planting of trees. Further improvements were made in 1898 with the creation of the York Board of Park Commissioners.

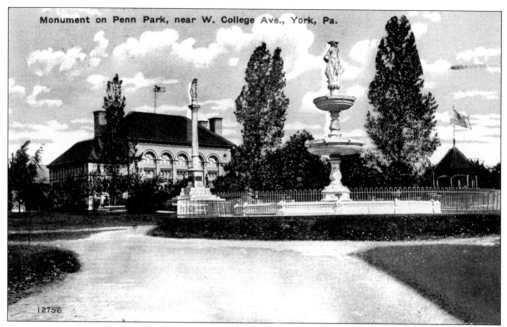

Monument on Penn Park, near W. College Ave., York, Pa.

12756

This postcard view shows the *Rebecca at the Well* fountain, Soldiers & Sailors monument, bandstand, and York High School in the distance. Only the Soldiers & Sailors monument remains today.

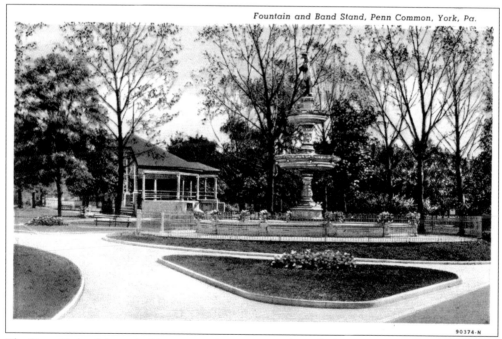

Fountain and Band Stand, Penn Common, York, Pa.

90374-N

The Penn Park of the early 21st century in many ways bears little resemblance to the Penn Park of the early 20th century. Fountains, pavilions, monuments, and well-manicured walkways made the park an important gathering place 100 years ago.

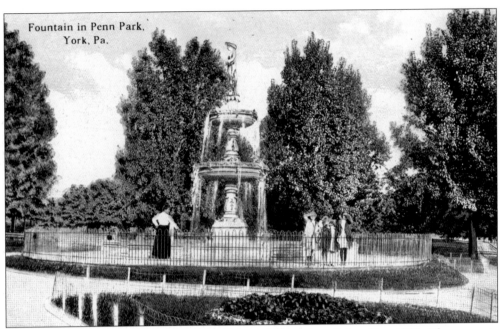

Fountain in Penn Park, York, Pa.

This fountain, known as *Rebecca at the Well*, was dedicated on Labor Day 1898. The concrete basin was 30 feet in diameter, and the ironwork came from the Variety Iron Works plant in York. In fact, the plant's owner, E. G. Smyser Sons, contributed $2,500 for the fountain, which eventually fell into disrepair and was sold and removed from the park in 1960.

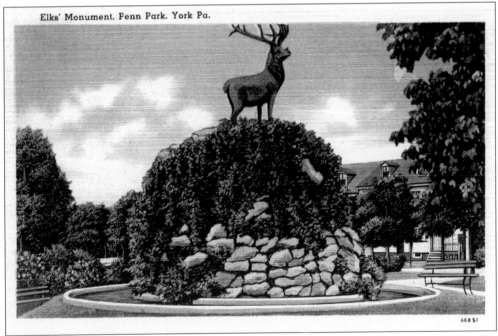

Elks' Monument, Penn Park, York Pa.

As part of the late-19th-century upgrades, the Benevolent Order of the Elks contributed $2,200 for a rockery and fountain, seen here topped with a statue of an elk.

The 65-foot-tall Soldiers & Sailors monument was dedicated on June 15, 1898, at a cost of $23,500. The monument, which was funded by the York County Commissioners and topped with the statue of Victory, was dedicated to the memory and patriotism of the soldiers and sailors who fought in the Civil War. Local architects J. A. and Reinhardt Dempwolf designed the striking monument.

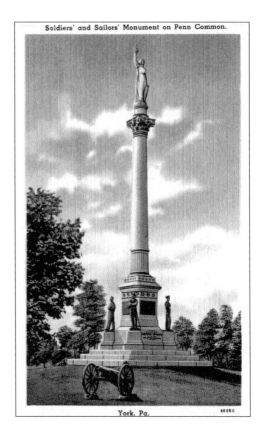

Soldiers' and Sailors' Monument on Penn Common.

York, Pa.

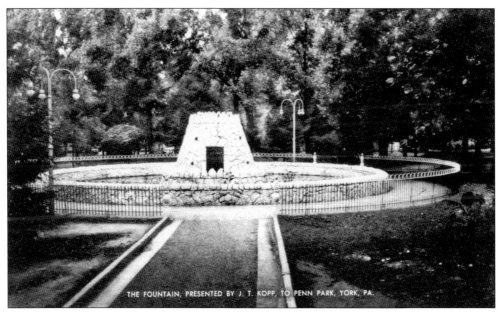

THE FOUNTAIN, PRESENTED BY J. T. KOPP, TO PENN PARK, YORK, PA.

J. T. Kopp, general manager of York Knitting Mill Company and director of Security Trust Company, presented a fountain to Penn Park as part of the park's improvements. The electric fountain cost $2,200.

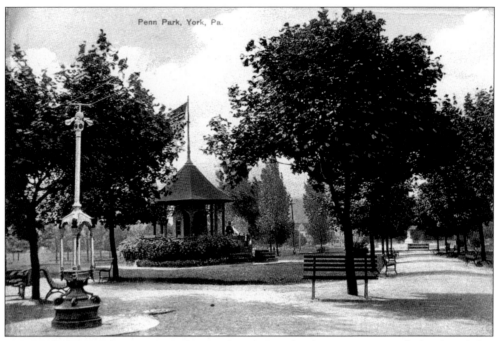

A group known as the Ivy Minstrels contributed $800 for the construction of a bandstand that became a popular spot for summer concerts. The York City Band and Spring Garden Band were just two of the acts that regularly performed here.

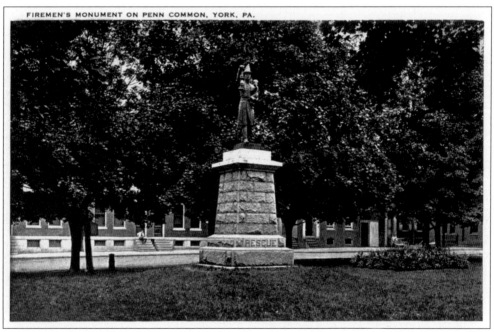

FIREMEN'S MONUMENT ON PENN COMMON, YORK, PA.

In 1900, the Rescue Fire Company erected a memorial to all firemen. The monument included a large granite pedestal and a life-size bronze fireman carrying an infant child.

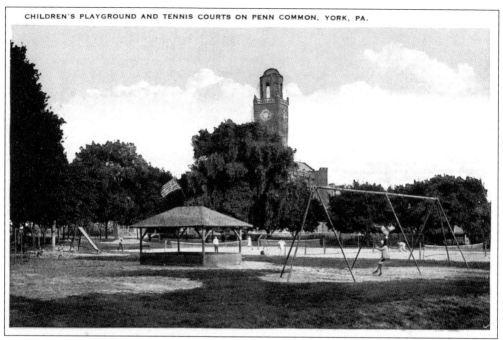

In addition to the beautiful walkways, monuments, and fountains, Penn Park also offered recreational activities, including tennis for the adults and a playground for children. Note how the tennis courts are not fenced in. The church in the background is Zion United Church of Christ, constructed in 1913.

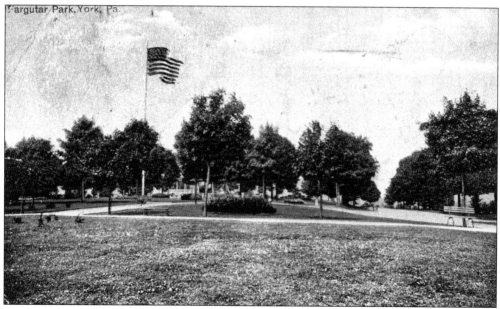

Fargutar Park, York, Pa.

A. B. Farquhar donated one acre to the city for use as a park in 1897. The York Improvement Company, a group of enterprising citizens, was able to obtain additional land for the creation of a 32-acre park. With the establishment of the York Board of Park Commissioners one year later, the vision for a sprawling park came closer to reality. More than 1,500 people attended the dedication of the park that same year.

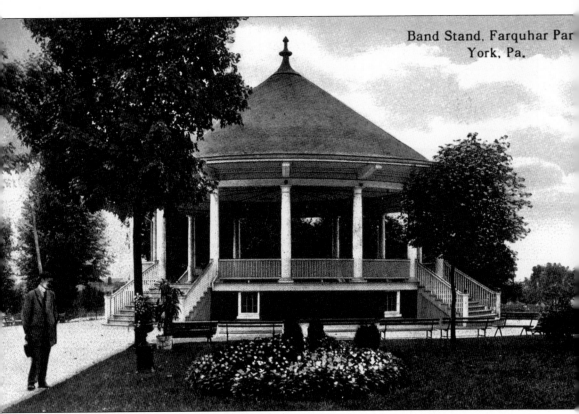

The striking bandstand was designed by the firm of Hamme and Leber and was dedicated in July 1903. The bandstand featured a polychromatic slate roof and a circumference of 150 feet. Over the course of the next century, the bandstand played host to scores of concerts, weddings, and family reunions. Eventually, it fell into a state of disrepair, however, and was closed to the public. Fortunately, Historic York Incorporated worked to restore this gem, which became a reality with the rededication of the bandstand in 2002.

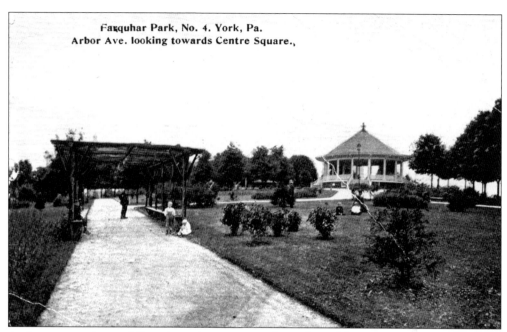

Farquhar Park, No. 4. York, Pa.
Arbor Ave. looking towards Centre Square.,

A picturesque arbor and fenced tennis courts were just a few of the amenities at Farquhar Park. The first tennis court was constructed c. 1907 and paid for by Thomas W. Shipley, an executive with the York Manufacturing Company who went on to open the York Shipley Company with his brothers.

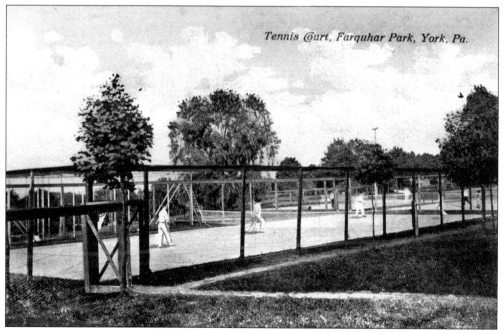

Tennis Court, Farquhar Park, York, Pa.

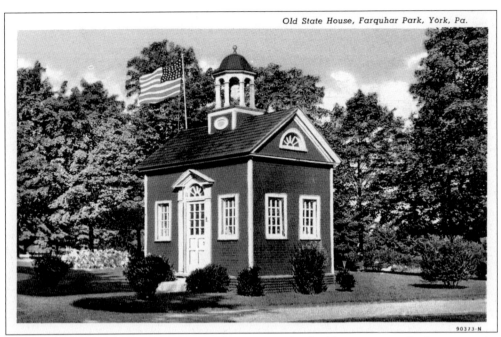

Old State House, Farquhar Park, York, Pa.

90373-N

Despite the postcard caption of "Old State House," this building was actually known as the "Little Courthouse." For many years it stood on the southeast corner of Centre Square; it was a gathering point for World War I efforts, including the sale of war stamps.

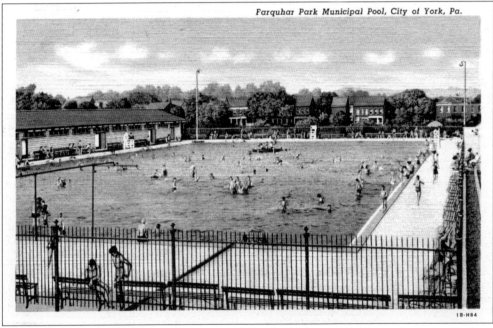

Farquhar Park Municipal Pool, City of York, Pa.

1B-H84

The York Municipal Pool, located adjacent to Farquhar Park, is better known to many Yorkers as the Boys' Club Pool. When constructed, the pool measured 125 feet by 27 feet, with depths ranging from 8 inches to 8 feet. A 35-foot-by-350-foot bathhouse with 1,000 steel lockers was also provided.

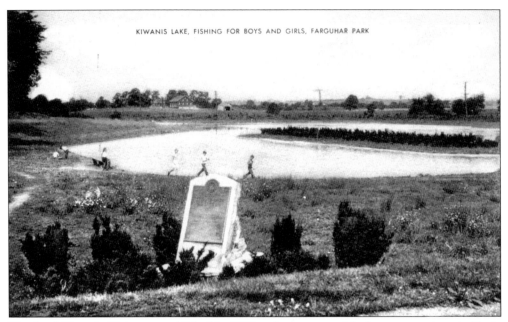

KIWANIS LAKE, FISHING FOR BOYS AND GIRLS, FARGUHAR PARK

The local Kiwanis Club was established in 1917 and was responsible for many projects in York, including the creation of comfort stations in Centre Square. Another project is pictured in this postcard—the conversion of a marshy tract bordering Farquhar Park into Kiwanis Lake, a popular fishing spot for youth.

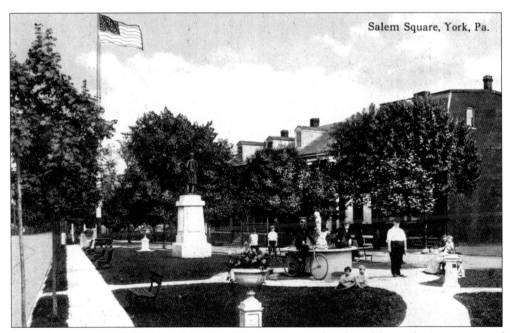

Salem Square, York, Pa.

Salem Square was established in the early 1900s on a triangular-shaped lot at the intersection of West Princess Street and Salem Road. A monument was erected in honor of the York Rifles, who bravely fought in the American Revolution, War of 1812, and Civil War.

No. 6931.—Highland Park, York, Pa.

Highland Park is in many ways a forgotten part of York's history. In the late 19th and early 20th centuries, the park was a major tourist draw, growing into a full-fledged amusement park. It was located just southwest of today's York City limits along Zinn's Quarry Road and the Codorus Creek.

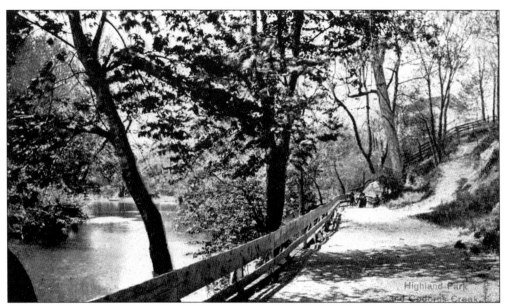

The Codorus Creek was a major draw to the park. A trolley loop encircling the park was added in 1895 to provide sightseeing along the Codorus Creek, and moonlight rides around the park became a popular activity.

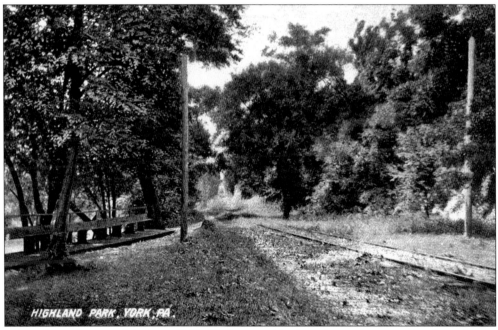

When the park opened in June 1890, Yorkers could take a horse-drawn trolley from Centre Square. The round trip cost 15¢. Two years later the first electric trolley was scheduled to make the trip to the park; unfortunately, a short circuit caused the trip to be cut short. The park became popular with Baltimoreans, too, who would ride the Ma & Pa Railroad into York City and then catch the trolley to the park.

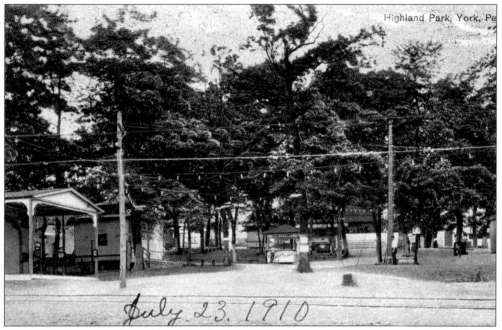

July 23. 1910

In 1907, Highland Park became a full-fledged amusement park with extensive amenities: roller coaster, theater, dance hall, skating rink, merry-go-rounds, circular swing, refreshment stands, and more. When the park closed, the theater and skating rink found new homes in York City, while the roller coaster and other amusement park amenities were sold to a park in Ohio.

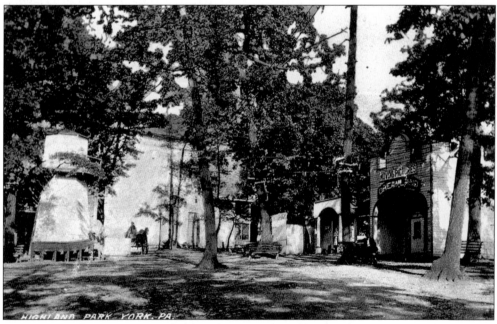

A summer stock company provided live theater, and Highland Park opened one of York's first movie theaters—located to the right, with the sign "Moving Pictures."

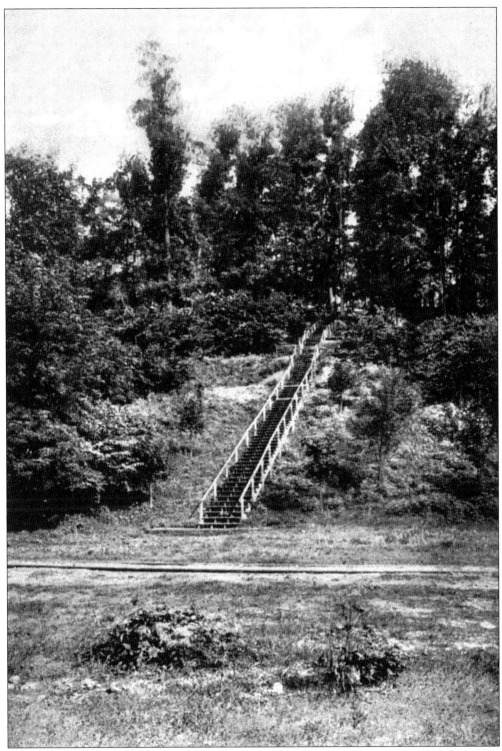

A total of 160 steps connected the lower part of the park with the upper part of the park. The physically exhausting stairs came to be known as "Fat Man's Misery."

Highland Park was owned by the York Street Railway Company, which owned the trolleys. It was the trolley service that allowed the park to grow from picnic park to amusement park. The decline of the trolleys spelled the end of the park. The site of the park was attractive to another type of business, and today, Highland Park is literally gone, home to a quarry.

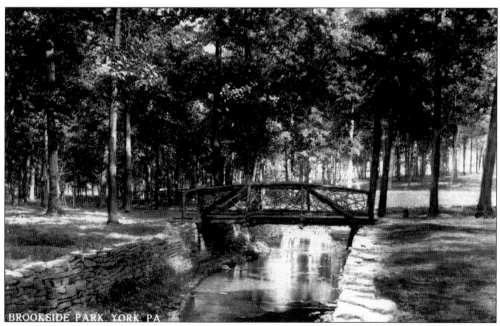

In addition to Highland Park, the York Street Railway Company established several other parks. These included Springwood Park, Cold Springs Park, and Brookside Park, which was located near Dover.

Eight
CODORUS CREEK

In many ways, York owes its existence to the Codorus Creek. In 1741, York was laid out, patterned after Philadelphia, at the point where wagons on the Monocacy Road could easily cross the Codorus Creek. The Monocacy Road followed an old Indian trail, beginning in Wrightsville and ending on the banks of the Monocacy River in Frederick, Maryland. Ever since York was founded, the Codorus has been a popular destination for recreation, although it has also experienced its share of industrial waste. In addition, several devastating floods have occurred. One of the earliest was the 1786 Pumpkin Flood. This October flood deposited scores of pumpkins on the banks of the Codorus. And one of the most recent floods is still vividly recalled by many locals: the 1972 Tropical Storm Agnes flooding, which caused extensive damage.

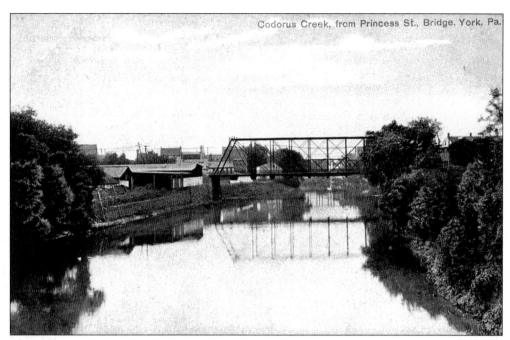

Codorus Creek, from Princess St., Bridge, York, Pa.

This Princess Street view looks northward toward King Street and Market Street in the distance. After the devastating flooding in 1884, the York County Commissioners placed iron bridges over the Codorus Creek at Penn, Princess, King, Market, Philadelphia, and George Streets.

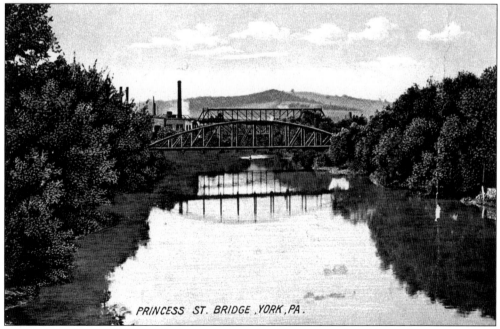

PRINCESS ST. BRIDGE, YORK, PA.

This view is from King Street looking southward. The summit of Webb's Hill is visible in the distance. During the Confederate occupation of York, four cannons were placed near the summit to guard against an approach of the federal army. Today, Webb's Hill is better known as Wyndham Hills.

110

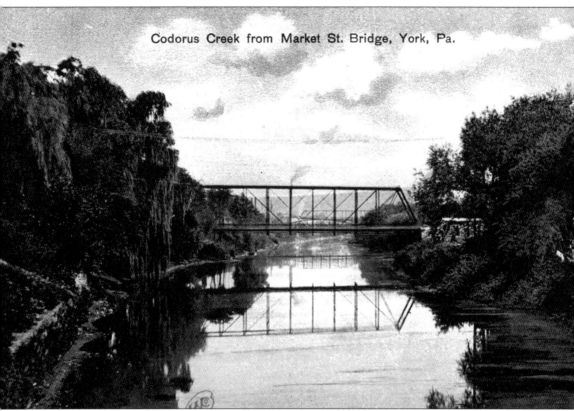

Codorus Creek from Market St. Bridge, York, Pa.

This view looks southward toward the King Street Bridge. Over the years flooding destroyed several Market Street bridges. In 1822, some 18 inches of snow fell, followed by heavy rains. High water and large chunks of floating ice destroyed three arches of the bridge. A flood in 1884 washed away all bridges over the Codorus, as well as many bridges and buildings upstream. At the time, the Codorus was approximately 80 feet wide at Market Street. During the flood it grew to approximately a quarter mile in width.

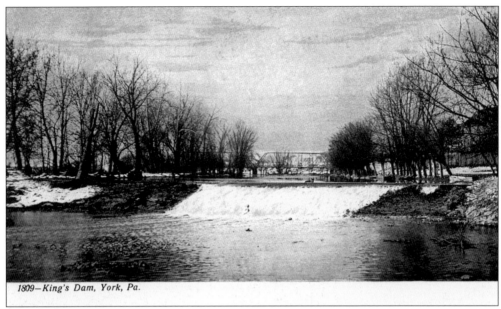

1809—King's Dam, York, Pa.

Established in 1798 by Philip King at the convergence of Tyler Run and the Codorus Creek, King's Mill was the site of a paper mill for almost 200 years. King's Dam was heavily damaged in a major 1933 flood and was subsequently removed in a project to deepen and widen the Codorus Creek.

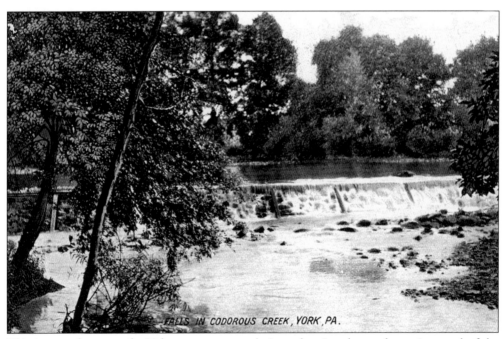

FALLS IN CODOROUS CREEK, YORK, PA.

This is one of many early-20th-century postcard views showing the rural, scenic appeal of the Codorus Creek. At one time there were over 100 dams, most of them small and made from wood, earth, and stone.

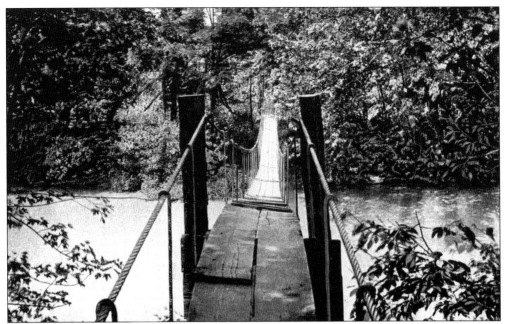

The Swinging Bridge over the Codorus Creek was located not far from present-day Interstate 83. The York Safe & Lock Company, which had a plant on Loucks Mill Road, constructed the bridge so employees living in North York could easily cross from the west bank to the east bank of the Codorus. The bridge was most likely destroyed in the 1933 flood.

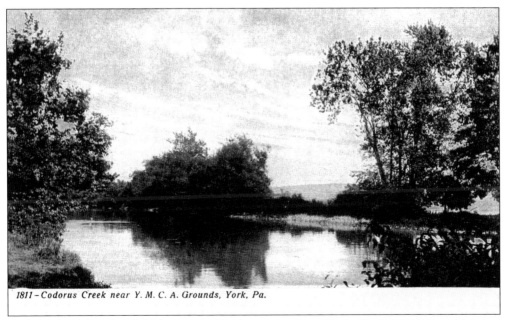

1811 – Codorus Creek near Y. M. C. A. Grounds, York, Pa.

In the early 1900s, the YMCA occupied land upstream from York. The YMCA Boat Club was one of several popular boat clubs in the area.

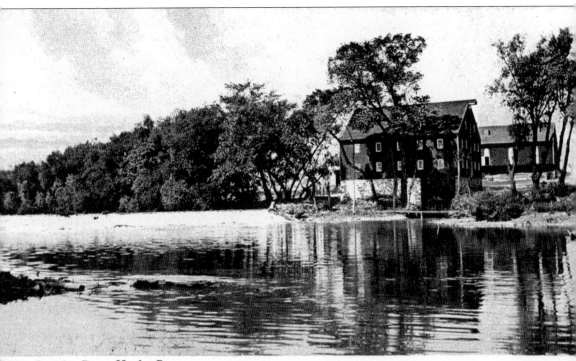

806—Laucks Dam, York, Pa.

The original Loucks Mill was constructed in 1791 by Philip Albright. The stone mill was enlarged in 1847 by George Loucks and leased to the firm of P. A. & S. Small. During the Confederate occupation of York, Southern troops took possession of the mill, using flour to make bread to feed the soldiers. They paid for the flour they used—but in Confederate currency. The mill burned in 1864, and a new brick mill was constructed in its place.

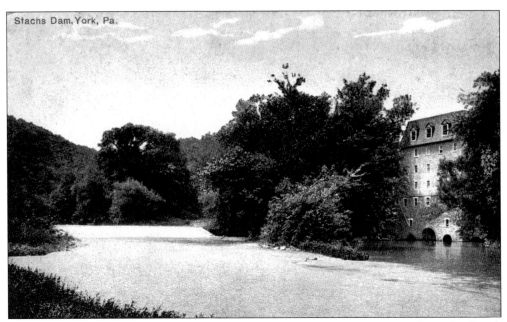

What is labeled here as "Stachs Dam" appears to be at the Loucks's Codorus Mill, north of York City. The Loucks family owned several mills along the Codorus Creek, two of which were seized by the Confederate army in 1863.

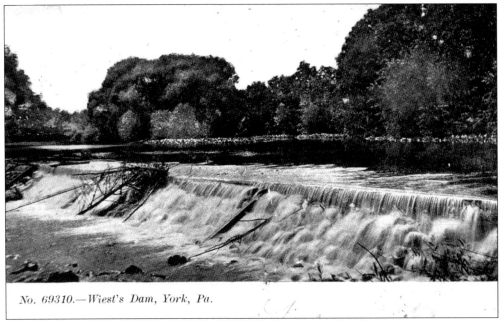

No. 69310.—Wiest's Dam, York, Pa.

Wiest's Dam was located on the west branch of the Codorus Creek, not far from present-day Indian Rock Dam. A mill located here was known over the years as Stoner's Mill, Klinedinst Mill, and Bender's Mill. The first mill was constructed in 1772, and the last one ceased operation in the early 20th century.

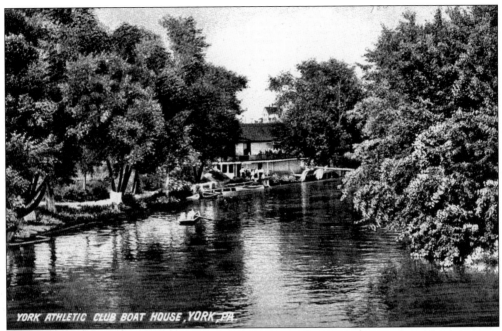

The York Athletic Club was located along the Codorus Creek, just east of Richland Avenue. The nearby King's Mill Dam impounded water, making it attractive for canoeing.

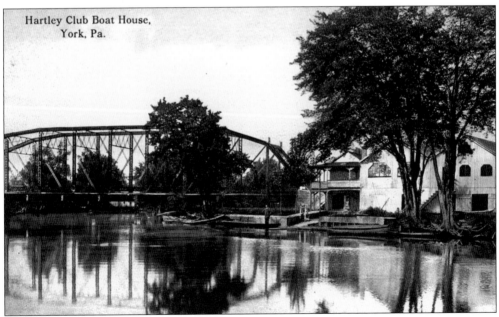

Another boat club near Richland Avenue was the Hartley Club. Boat parades were a popular summertime activity drawing hundreds of spectators. Canoes from the boat clubs were decorated and paddled toward the downtown. Participants had to remove the canoes from the water to pass around the dams.

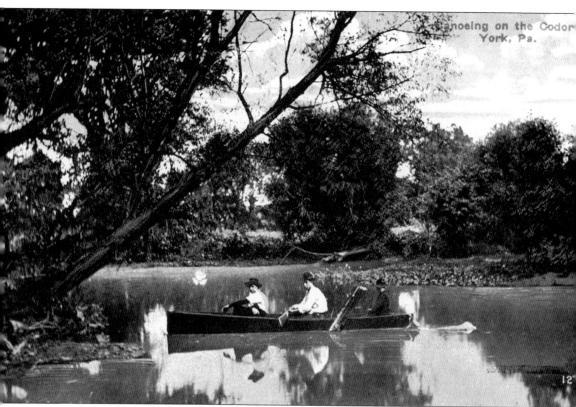

This tranquil scene shows the true beauty of the Codorus Creek, demonstrating why it has been an attraction for Yorkers for over 250 years.

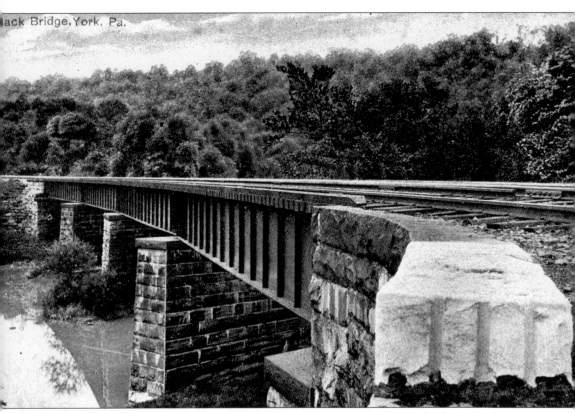

The Black Bridge is a railroad bridge that crosses the Codorus Creek north of present-day Route 30, near the Codorus Mill. The bridge is visible today from Black Bridge Road.

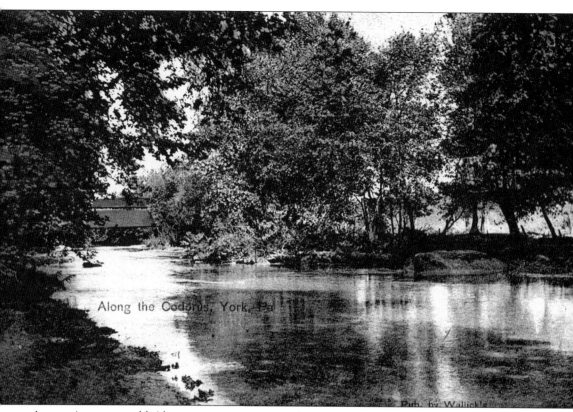

Along the Codorus, York, Pa

Pub. by Wallick's

At one time, covered bridges were a common site throughout York County. In fact, one of the longest covered bridges in the world spanned the Susquehanna River between Wrightsville, York County, and Columbia, Lancaster County. This bridge was destroyed during the Civil War. In downtown York, High Street once featured a covered bridge. High Street was the early name for Market Street.

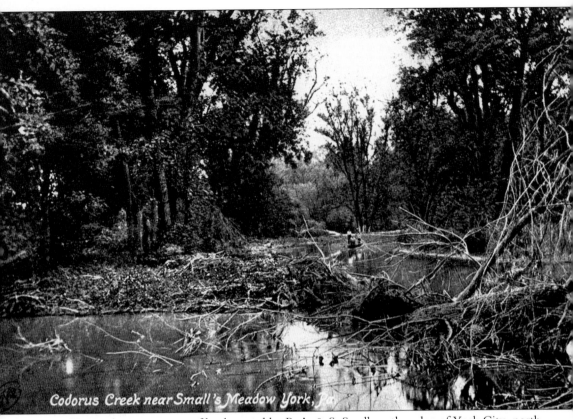

Codorus Creek near Small's Meadow York, Pa.

Small's Meadow was a tract of land owned by P. A. & S. Small on the edge of York City, north of the Codorus Creek and east of George Street. In 1884, a major flood piled debris two stories high in the meadow. Lumber, chairs, stoves, and even several bridges that had washed away upstream were deposited here. Today, Small's Meadow is better known as Small's Field, location of an athletic complex.

Nine

YORK FAIR

"America's First Fair" is almost as old as York itself and older than the United States. In 1765, Thomas Penn granted a charter to the people of York to hold a twice-yearly fair, one in spring and one in fall. Two-day agricultural fairs were held on Penn Common. The tradition continued until 1815. In 1853, the York County Agricultural Society was formed and the fair was revived. That year a three-day fair was held on Penn Common. Fairgrounds were established southeast of South Queen and East King Streets, with the first fair held there in 1856. In 1888, some 73 acres off West Market Street were purchased for new, larger fairgrounds. The fair was expanded to five days in 1926. In 1942, the fair moved from its traditional month of October to early September. The fair was expanded to nine days in 1975 and to 10 days in 1997.

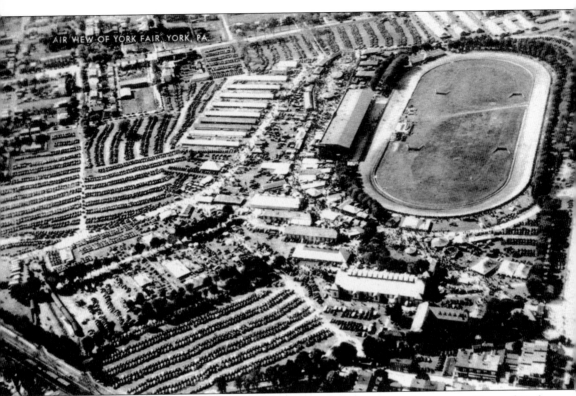

In 1888, the York County Agricultural Society purchased 73 acres on the western fringe of York City and relocated the fairgrounds, where the York Fair has been held ever since. The fair was canceled in 1918 due to a severe influenza outbreak; in fact, the fairgrounds became a temporary hospital during the crisis.

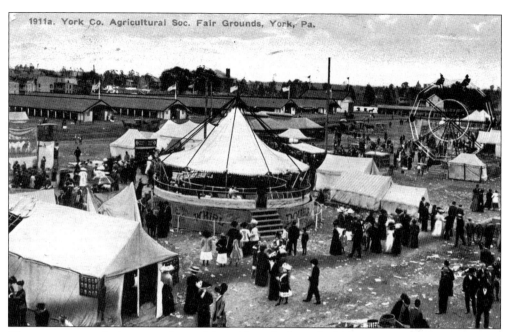

These two postcards showcase views of the midway in the early 20th century. The livestock barns are visible in the background of the upper postcard. Note how well dressed the fairgoers are—a far cry from the jeans and T-shirts typical of today.

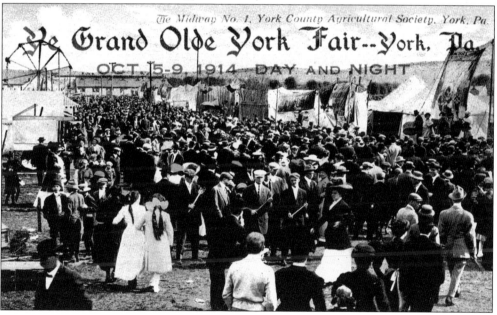

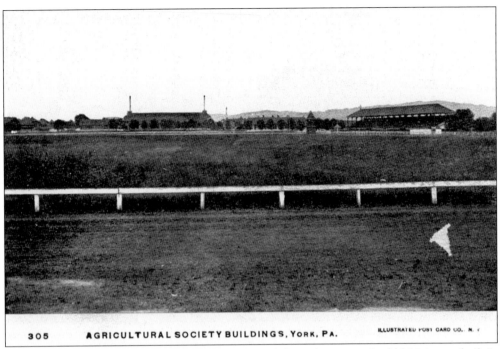

This postcard provides an overview of the fairgrounds from the racetrack. Old Main was built in 1888, and Horticultural Hall was constructed two years later.

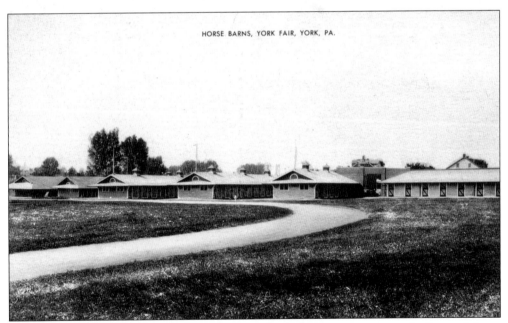

HORSE BARNS, YORK FAIR, YORK, PA.

This view shows the horse barns along the racetrack, similar in appearance to the livestock barns located near the midway. Those barns housed exhibits of sheep, cattle, and swine during the fair. The livestock barns disappeared into history to make way for a major new arena, which was completed in 2003.

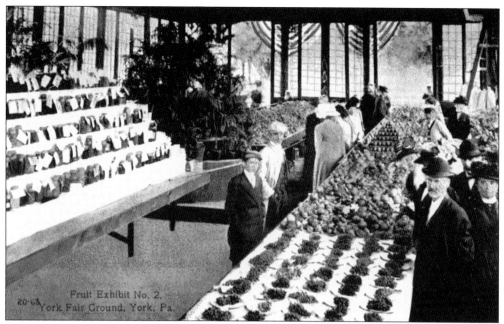

Fruit Exhibit No. 2.
York Fair Ground, York, Pa.

Agricultural and horticultural exhibits have long been a tradition at the York Fair, drawing thousands of entrants annually. In fact, one of the permanent fairgrounds buildings is named Horticultural Hall. The fair's old slogan was "It Has Everything," as evidenced by the diverse array of fresh and jarred fruits in these postcards.

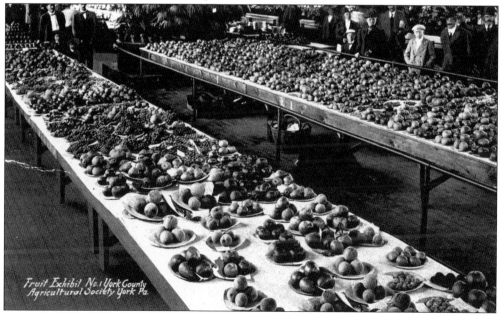

Fruit Exhibit No. 1 York County Agricultural Society York Pa.

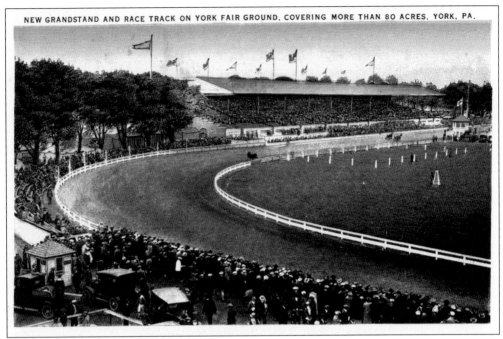

A new grandstand was constructed in 1926, and that same year the York Fair was expanded to a five-day annual event, beginning on Tuesday and ending on Saturday. Until 1928, the fair was primarily a daytime event. That year the fair remained open three nights, and by 1932, the fair was open every night.

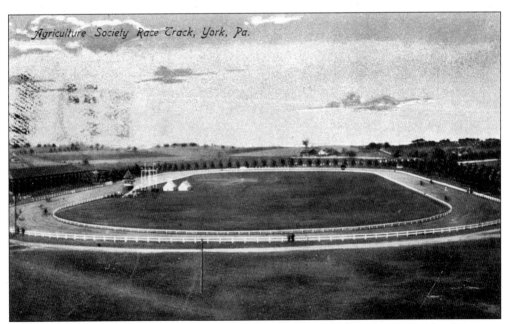

Agriculture Society Race Track, York, Pa.

Today, fairgoers flock to the racetrack nightly to enjoy grandstand concerts by big-name performers. In years past the racetrack has hosted events such as horse racing and even automobile racing.

BIBLIOGRAPHY

Gulden, Dave. *Old York Times #1*. York, PA: Dave Gulden, 2002.

McClure, James. *Never to Be Forgotten*. York, PA: York Daily Record, 1999.

Peckham, Betty. *The Story of a Dynamic Community: York, Pennsylvania*. York, PA: York County Chamber of Commerce, 1945.

Peckham, Betty. *York Pennsylvania: A Dynamic Community Forges Ahead*. York, PA: York County Chamber of Commerce, 1957.

Prowell, George R. *History of York County, Pennsylvania*. Chicago: J. H. Beers & Company, 1907.

Roe, Frederick B. *Atlas of the City of York, York County Pennsylvania*. Philadelphia: Frederick B. Roe, 1903.

Sheets, Georg R. *Made in York: A Survey of the Agricultural and Industrial Heritage of York County, Pennsylvania*. York, PA: Agricultural and Industrial Museum of York County, 1991.

———. *To the Setting of the Sun: The Story of York*. Windsor, PA: Windsor Publications, 1981.

Springettsbury Township Centennial Committee. *Springettsbury Township Centennial, 1891–1991*. York, PA: Anstadt Printing Craftsmen, 1991.

Taub, Lynn Smolens. *Greater York in Action*. York, PA: The York Area Chamber of Commerce, 1968.

West Manchester Township Bicentennial Book Committee. *West Manchester Township 200th Celebration*. York, PA: West Manchester Township Board of Supervisors, 1999.

Wilson, Kristine M. *National Register of Historic Places Nomination Form: York Armory*. Harrisburg, PA: Pennsylvania Historical and Museum Commission, 1989.

York City Fire Department. *Two Centuries of Dedicated Services to the Citizens of York, 1776–1976*. York, PA: York City Fire Department, 1976.

Pamphlets and Unpublished Works

Butcher, Scott D. *York's Historic Buildings*. York, PA: Unpublished, 2005.

Meckley, Daniel G. III, "The Codorus." York, PA: Unpublished, 2000.

Memorial Souvenir Commemorating the 150th Anniversary of York as the Capital of the United States of America, 1777–1778. York, PA: Conservation Society of York County, 1927.

York Historic District Revised Resource Inventory, 2001–2002.

Online Sources

http://www.ccyork.com. History of the Country Club: Where History Meets Tradition.

http://www.virtualyork.com. Virtual York: A Journey through History.

http://www.yorkfair.org/history.htm. The York Fair: America's First, America's Oldest Fair.

http://www.yorkfirst.org/overview.shtml. York First Church of the Brethren History.